TREASURES OF THE

HERMITAGE

TREASURES OF THE

HERMITAGE

Introduction by Vitaly A. Suslov

A TINY FOLIO™
ABBEVILLE PRESS PUBLISHERS
NEW YORK LONDON PARIS

Front cover: Detail of Paul Gauguin, *Eu Haere ia oe (Woman with Fruit),* 1893. See page 253.

Back cover: Caravaggio, *The Lute Player,* c. 1596. See page 207.

Spine: *Bull Figurine.* Northern Caucasus, early 3d millennium B.C. (early Bronze Age). See page 28.

Frontispiece: Detail of Jean-Honoré Fragonard, *The Stolen Kiss,* late 1780s. See page 231.

Page 6: View of the Hermitage from the Neva River.

Page 11: The Ambassador's Staircase in the Winter Palace.

Page 15: The portico of the New Hermitage.

Page 16: Detail of *Comb.* Southern Russia (Scythian burial mound, Dnieper Valley), early 4th century B.C. See page 33.

Page 60: Detail of *The Gonzaga Cameo.* Egypt (Alexandria), 3d century B.C. See page 93.

Page 102: Detail of *Yama's Hell.* Tibet, 17th–18th century A.D. See page 131.

Page 146: Detail of Bartolomeo Carlo Rastrelli, *Portrait Bust of Peter I,* 1723–29. See page 159.

Page 190: Detail of Peter Paul Rubens, *Bacchus,* 1636–40. See page 221.

Page 236: Detail of Claude Monet, *Lady in a Garden (Ste-Adresse),* 1867. See page 256.

For copyright and Cataloging-in-Publication Data, see page 287.

CONTENTS

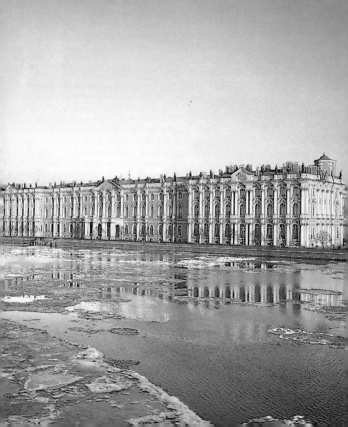

INTRODUCTION

In 1764 Catherine the Great, empress of Russia (1762–96), acquired from Berlin a magnificent collection of 225 paintings by Dutch and Flemish masters. This purchase became the nucleus of Catherine's private collection, housed in her new royal residence on the banks of the Neva River in St. Petersburg—the Winter Palace. Designed by Italian architect Bartolomeo Francesco Rastrelli, this immense baroque building was completed in 1762. The gallery itself was known as the empress's *ermitage,* French for "place of seclusion," and over more than two hundred years it has developed into one of the world's largest and most impressive museums—the State Hermitage.

Though Catherine was the driving force behind the royal collection based at the Winter Palace, it was Peter the Great (1682–1725) who played the pioneering role. Peter's vision for his new capital city, founded in 1703 and built on marshy, inhospitable land by the Gulf of Finland, was to "open a window to the West." St. Petersburg duly became a cultural and artistic center with foreign architects and artists responsible for many of the palaces and public buildings. Peter started to amass a personal art collection and founded the Kunstkammer, or Museum of Natural History, Russia's first public museum. It was

with the reign of Catherine, however, that the arts took on new importance as she began to promote private patronage as an aspect of state policy.

The foundation of the Hermitage—a direct result of the Age of Enlightenment—was part of this cultural renaissance, and during the second half of the eighteenth century the museum's collections expanded rapidly. In 1768 the private collection of Count Karl Cobenzl, which included more than four thousand drawings, was purchased in Brussels; the following year some six hundred Flemish, Dutch, and French paintings were sold to Catherine by the heirs of Count Heinrich von Brühl, a Dresden connoisseur. Not all of these royal purchases found their way to St. Petersburg: in 1771 a number of important Dutch paintings acquired for Catherine by Prince Dmitry Golitsyn in Amsterdam were lost when the ship carrying them capsized in the Baltic Sea.

In 1772 the Hermitage acquired one of the most important European art collections of the eighteenth century, that of the French banker Baron Crozat. Further significant acquisitions were made with the help of Catherine's distinguished foreign advisers, including the French philosopher Denis Diderot. These additions included the celebrated collection of the former British prime minister Sir Robert Walpole, purchased in 1779,

and that of Count Baudouin, acquired in Paris in 1781. Apart from these major collections, Catherine also commissioned a number of celebrated artists to produce works expressly for the Russian collection, among them Chardin and Sir Joshua Reynolds.

Although the Hermitage is justly renowned for its paintings, it would be wrong to concentrate solely on this aspect of the empress's acquisitions. The extraordinary wealth of the Hermitage's collections of engravings, coins and medals, gemstones, minerals, and books (including the complete libraries of Diderot and Voltaire) is in large part due to her.

To house the ever-increasing number of works of art, new buildings were added to the Winter Palace along the Neva embankment: the Small Hermitage, completed in 1769, and the Great, or Old Hermitage, as it became known, in 1787. Also in 1787 the Hermitage Theater was erected on the site of Peter the Great's original Winter Palace, and connected to the Old Hermitage by an arched bridge spanning the Winter Canal.

The private art collection of Catherine acquired the status of an imperial museum during the reigns of her son, Paul I (1796–1801), and her grandson, Alexander I (1801–25). In 1814, taking advantage of political turmoil in France, Alexander I acquired thirty-eight works from the Empress Josephine's collection at Malmaison. In the

same year the first Spanish paintings entered the museum through the purchase of the well-known collection of the Dutch banker W. G. Coesvelt.

The first half of the nineteenth century marked a new stage in the development of the Hermitage, for over that period a great many classical and Oriental antiquities were added to the museum's collections, together with finds from contemporary archaeological excavations in the northern Caucasus, Crimea, and southern Ukraine. Most notable among these are the treasures of the Bosporan Kingdom, found at the famous Kerch burial mound of Kul Oba. Further finds in the Crimea and the Kuban basin provided the museum with perhaps its most famous collection of antiquities, the Scythian gold.

The period also marked a new turn in a more dramatic and terrible way. On December 17, 1837, fire broke out in the Winter Palace. It raged for three days, but thanks to the heroic efforts of firefighters, the Hermitage building was saved, together with a considerable number of the Winter Palace's priceless items. Thousands of craftsmen participated in the restoration of the palace, and by November 1839 it became once again the winter residence of the emperor, then Nicholas I (1825–55).

In 1852 Nicholas inaugurated a major new museum building. The New Hermitage, as it was called, was designed by Munich-born architect Leo von Klenze. The portico

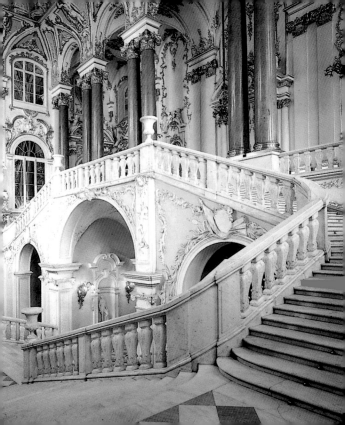

facing onto Millionaya Street was adorned with ten 16½-feet-high atlantes, carved out of whole blocks of granite by the sculptor Alexander Terebenev. With this new building came a reorganization of the museum's collections, as the Hermitage was now a public museum, formally separated from the Winter Palace residence. An up-to-date inventory was taken and a catalog compiled, and for the first time Russian art was acknowledged to be worthy of its own department, as was the collection of classical art.

The Hermitage made a number of important acquisitions in the mid-nineteenth century, including some fine paintings by Titian that were part of a collection acquired from the Barbarigo Palace in Venice; Leonardo's *Madonna and Child (Madonna Litta)*, purchased in 1865 from Count Litta in Milan; and Raphael's *Madonna and Child (Conestabile Madonna)*, bought from Count Conestabile della Staffa in Perugia in 1871. In 1884 the museum also acquired the wonderful Oriental, Byzantine, and medieval works of art that made up the collection of Anton Basilevsky. A year later the collection of arms and armor from the Tsarskoye Selo armory was added to the museum's many treasures.

The acquisitions did not cease in the twentieth century. In 1910 the vast collection of some seven hundred Dutch and Flemish works that belonged to the famous traveler and geographer Semyonov Tian-Shansky was

bought for the museum; four years later Leonardo's *Madonna with a Flower* was purchased from the Benois family collection in St. Petersburg, and consequently became known as the *Benois Madonna*.

The fortunes of the Hermitage changed drastically in 1917. After the February Revolution the museum was renamed the "ex-imperial Hermitage." Kerensky's Provisional Government ordered that the art collection and all the property of the Winter Palace be moved to Moscow, where it was stored in the Kremlin and the History Museum in Red Square. On the night of October 25, 1917, the Winter Palace, in which sessions of the Provisional Government had been held since the summer, was stormed by revolutionary forces and the government members were arrested. A few days later the new Soviet government designated the Winter Palace and the Hermitage state museums. Eventually they were merged to form the Hermitage as it is known today.

Since the Revolution the museum's holdings have undergone many changes, not always for the better. Although nationalization brought to the Hermitage the unparalleled collections of Impressionist and Post-Impressionist paintings assembled by the great collectors Sergei Shchukin and Ivan Morozov, during the 1920s and 1930s the Soviet Commissariat for Foreign Trade frequently offered works of art to foreign officials and

businessmen for token sums. As a result, numerous works of art originally from the Hermitage are now in national and private collections the world over. Even the private library of Nicholas II (1894–1918), for example, was bought by the U.S. Library of Congress.

In 1941 Germany attacked the Soviet Union, precipitating Soviet involvement in World War II. So began the second wartime evacuation of the Hermitage, this time to Sverdlovsk in the Urals, and more than two million items were dispatched on two trains. Toward the end of 1944, with war still raging, a marvelous exhibition was mounted of all the treasures still in the Hermitage, which were saved by the museum staff often at the cost of their lives.

Today the Hermitage, with its collection of almost three million artifacts, many of them housed in 353 rooms of unrivaled splendor, is a remarkable testament to the history of one country and the art and culture of many. The small imperial collection established in the mid-eighteenth century and whimsically named a "hermit's refuge" by its crowned owners is now, at the end of the twentieth century, one of the world's largest and most magnificent museums.

Vitaly A. Suslov

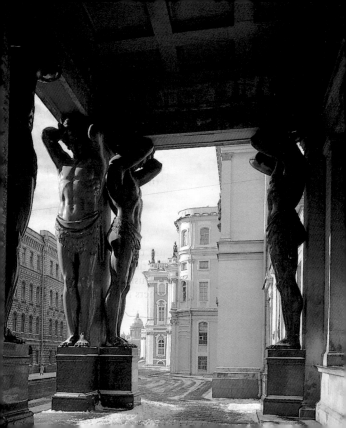

PREHISTORIC AND EARLY ART

For the last 150 years, the Hermitage has held one over-whelming advantage over other museums in assembling its collection of prehistoric and early art: a treasure lay buried in its own backyard, that is, within the borders of the Russian Empire and, subsequently, the Soviet Union. For example, in 1928, in the Siberian village of Malta, a settlement was discovered that yielded an astonishing trove of primitive art that proved to be one of the richest in the world. These artifacts, embracing diverse examples of Stone Age carving on bone and on small figurines, also included some ten representations of birds that have no parallel in Paleolithic art.

The Hermitage collection of early art spans thousands of years and covers thousands of miles, from the Malta settlement, which dates at least to the twentieth millennium B.C., to the treasures of Sarmatian tribes, which dominated the region north of the Black Sea around the first century A.D., to the jewelry of ancient Rus, created for princely families and the church by craftsmen from the tenth to the thirteenth century. Much of the intervening period presents a complex picture of early farming cultures, nomadic tribal movements, and, around the Black Sea and the Pontic Steppe, Greek influence and imports.

Excavations in many regions of the former Soviet Union have revealed extraordinary riches that have influenced our understanding of these ancient peoples as much as they have fascinated visitors to the Hermitage.

In 1869, in the small village of Koban in the Caucasus, a burial ground was discovered that contained bronze items of a kind previously unknown. Later, further sites were located in the central Caucasus that provided evidence of a strikingly rich, ancient culture dating from the ninth to the fourth century B.C., now referred to as the Koban culture. Hundreds of bronze battle-axes, daggers, spearheads, bridle decorations, belt buckles, and all manner of pendants and bracelets were found.

More remarkable still are the results of nineteenth- and early twentieth-century excavations from burial complexes in the Crimea and the Kuban basin. From the seventh to the third century B.C., Scythian tribes dominated the steppes north of the Black Sea. At much the same time the Greeks began to establish colonies and cities on the sea's northern shores. Renowned for the vivid individuality of its Animal style, Scythian art reflected the mythology and the ethical and aesthetic ideals of the warrior-nomad; but discovered alongside this art were articles that display a unique Greco-Scythian style, immortalizing scenes from the everyday life of the Scythians. The most notable examples in the Hermitage are a golden comb from

the Solokha burial mound (pages 16 and 33) and a silver amphora from the Chertomlyk burial mound (page 35).

The Pazyryk burial mounds, discovered high up in the Altai mountains of Mongolia in 1924, provide further evidence of the extraordinary richness and diversity of Russia's ancient cultures. Sacrificial horses, complete with their harnesses, were discovered within these tumuli, as were domestic items such as folding wooden tables, flasks, and musical instruments. Mirrors and silks from China bear witness to the ancient Altaians' cultural and trade links with Central Asia and the Near East.

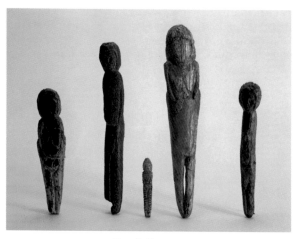

Female Figurines.
Siberia (near Irkutsk), 22d–20th millennium B.C.
(late Paleolithic). Mammoth ivory and northern deer horn,
height: 1⅝–5¼ in. (4.2–13.6 cm).

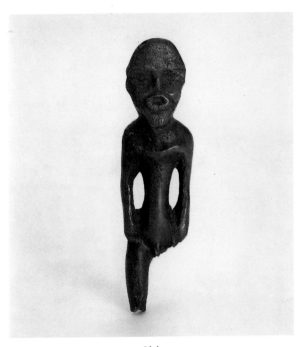

Idol.
Northern Russia (Pskov region), 4th millennium B.C.
Elk horn, height: 3⅝ in. (9.3 cm).

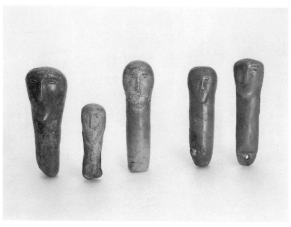

Stone Rods Decorated with Female Heads.
Siberia (near Krasnoyarsk), 1st half of the 2d millennium B.C.
(early Bronze Age). Stone, height: 1¼–1¾ in. (3.2–4.7 cm).

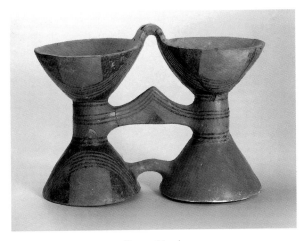

Pottery Vessel.
Moldova/Ukraine (Chernovtsy region), 2d half
of the 4th millennium B.C. Clay, height: 6 in. (15.5 cm).

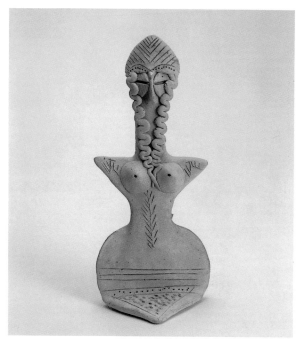

Female Figurine.
Southern Turkmenia, early 2d millennium B.C.
(early Bronze Age). Clay, height: 6¼ in. (16 cm).

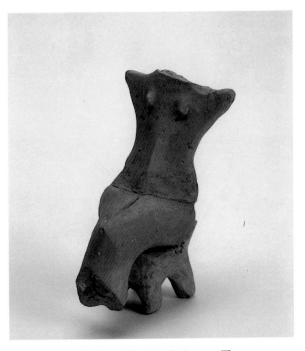

Torso of a Female Figurine, Sitting on a Throne.
Moldova/Ukraine (Ivano-Frankovsk region), 2d half
of the 4th millennium B.C. Clay, height: 4⅜ in. (11 cm).

25

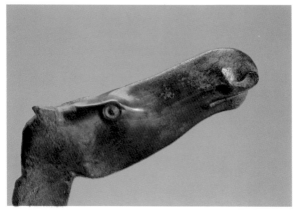

Head of a Female Elk.
Ural Mountains (Central Russia), 3d millennium B.C.
Elk horn, length: 7⅝ in. (19.5 cm).

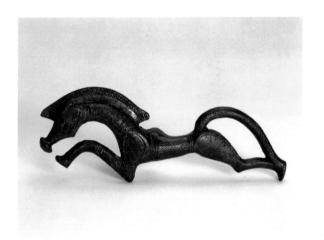

Belt Buckle.
Northern Ossetia (Koban), 1st half of the 1st millennium B.C.
(late Bronze Age). Bronze, length: 5 in. (12.9 cm).

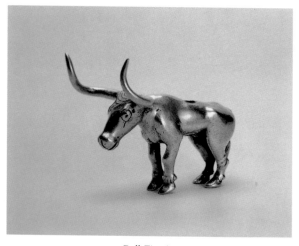

Bull Figurine.
Northern Caucasus, early 3d millennium B.C.
(early Bronze Age). Gold, height: 2⅜ in. (6 cm).

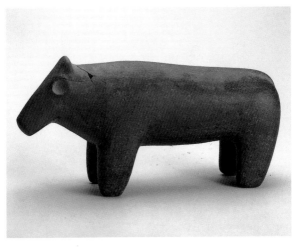

Bull Figurine.
Northern Caucasus, middle of the 3d millennium B.C.
(early Bronze Age). Stone, height: 5¼ in. (13.2 cm).

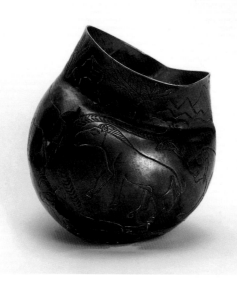

Vessel Decorated with a Landscape.
Northern Caucasus, early 3d millennium B.C.
(early Bronze Age). Silver, height: 3¾ in. (9.6 cm).

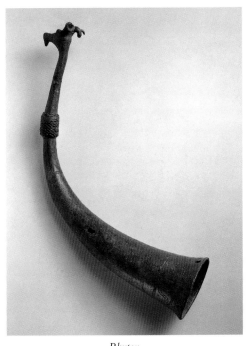

Rhyton.
Abkhazia, 8th–7th century B.C.
Bronze, length: 21¾ in. (55.5 cm).

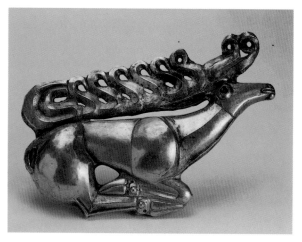

Shield Emblem.
Southern Russia (Scythian burial mound, Kuban area), late
7th–early 6th century B.C. Gold, length: 12½ in. (31.7 cm).

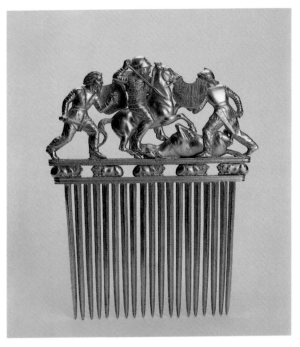

Comb.
Southern Russia (Scythian burial mound, Dnieper Valley),
early 4th century B.C. Gold, height: 5 in. (12.6 cm).

33

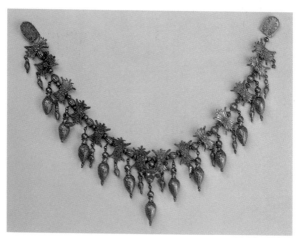

Necklace.
Southern Russia (Scythian burial mound, Kuban area),
late 4th century B.C. Gold, length: 17¾ in. (45 cm).

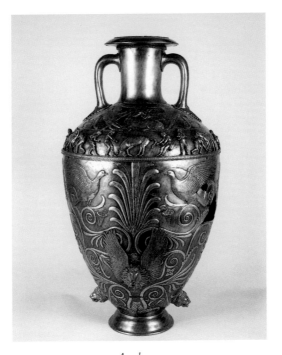

Amphora.
Ukraine (Scythian burial mound, Dnieper Valley),
late 4th century B.C. Silver, gilding, height: 27½ in. (70 cm).

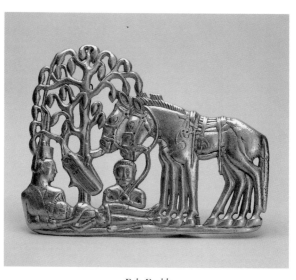

Belt Buckle.
Siberia, 6th–5th century B.C.
Gold, height: 4¾ in. (12.2 cm).

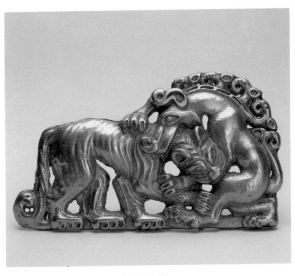

Belt Buckle.
Siberia, 7th century B.C.
Gold, length: 6⅝ in. (16.8 cm).

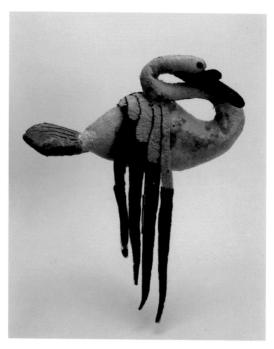

Swan.
High Altai (Pazyryk burial mound, Mongolia),
5th–4th century B.C. Felt, length: 13¾ in. (35 cm).

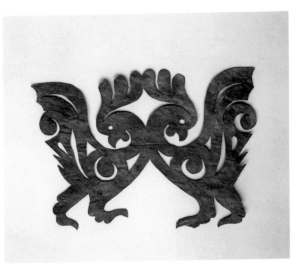

Appliqué Decoration in the Form of Two Birds.
High Altai (Pazyryk burial mound, Mongolia),
5th century B.C. Leather, width: 6¾ in. (17 cm).

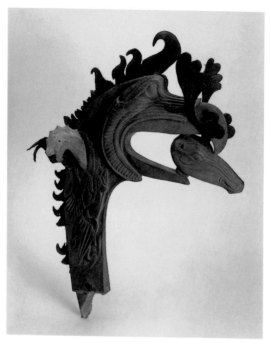

Terminal.
High Altai (Pazyryk burial mound, Mongolia),
5th century B.C. Wood, leather, height: 13¾ in. (35 cm).

40

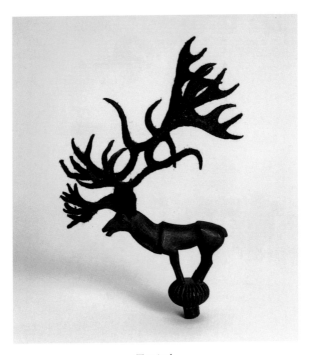

Terminal.
High Altai (Pazyryk burial mound, Mongolia),
5th century B.C. Wood, leather, height: 4½ in. (11.5 cm).

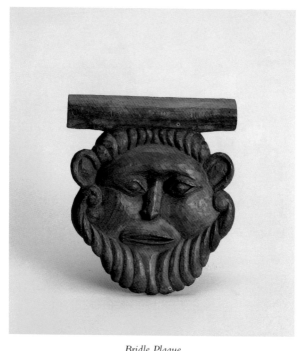

Bridle Plaque.
High Altai (Pazyryk burial mound, Mongolia),
5th century B.C. Wood, height: 4⅜ in. (11 cm).

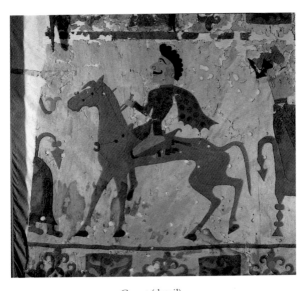

Carpet (detail).
High Altai (Pazyryk burial mound, Mongolia),
5th–4th century B.C. Felt, 15 x 21¼ ft. (4.5 x 6.5 m) overall.

43

Drinking Vessel.
Southern Russia (Sarmatian burial mound, Rostov area),
1st century A.D. Gold, turquoise, coral, glass,
height: 3 in. (7.5 cm).

44

Perfume Flask.
Southern Russia (Sarmatian burial mound, Rostov area),
1st century A.D. Gold, turquoise, coral, pearl,
height: 2¾ in. (7 cm).

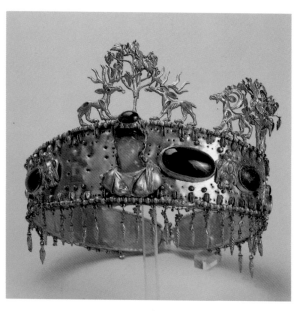

Diadem.
Southern Russia (Sarmatian burial mound, Rostov area),
1st century A.D. Gold, turquoise, coral, garnet, pearl, glass,
amethyst, length: 24 in. (61 cm).

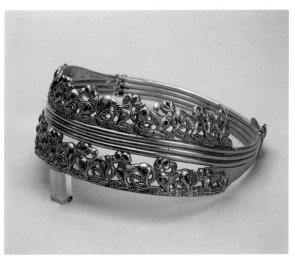

Neck Ring.
Southern Russia (Sarmatian burial mound, Rostov area),
1st century A.D. Gold, turquoise, coral, topaz,
diameter: 7 in. (17.8 cm).

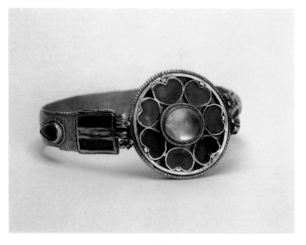

Bracelet.
Crimea (Kerch), late 4th–early 5th century A.D.
Gold, garnet, rock crystal, diameter: 2⅜ in. (6 cm).

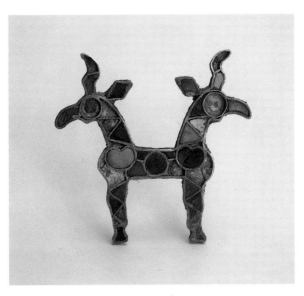

Ornamental Plaque.
Crimea (Kerch), late 4th–early 5th century A.D.
Gold, silver, garnet, height: 2⅝ in. (6.7 cm).

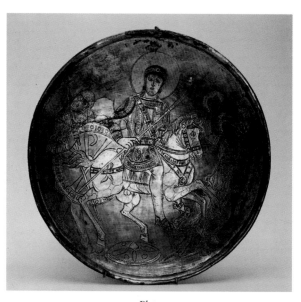

Plate.
Crimea (Kerch), 4th century A.D.
Silver, gilding, niello, diameter: 9¾ in. (24.9 cm).

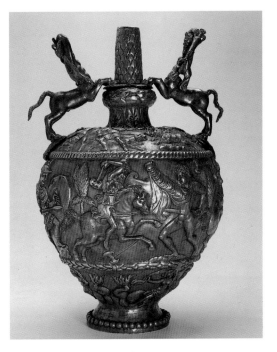

Vase.
Moldova, late 4th century A.D.
Silver, gilding, height: 16¾ in. (42.5 cm)

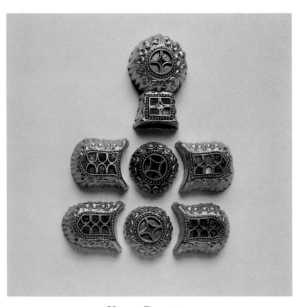

Harness Decorations.
Ukraine (Pereshchepina, near Poltava),
1st half of the 7th century A.D. Gold, bronze, glass, paste,
diameter of circular decorations: 1¼ in. (3.2 cm).

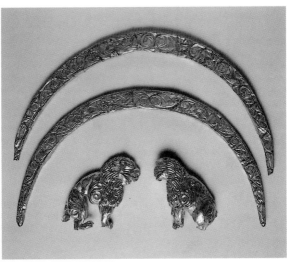

Ornamental Facings for Saddle Pommels.
Ukraine (Pereshchepina, near Poltava), mid-7th century A.D.
Gold, length of arc-shaped facings: 18 in. (46 cm).

53

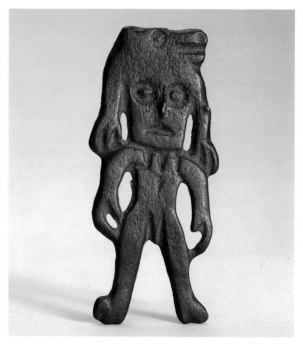

Figurine.
Russia (Perm Province), 1st–3d century A.D.
Bronze, height: 3¼ in. (8 cm).

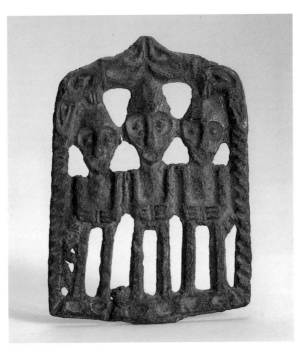

Plaque.
Russia (Perm Province), 6th–8th century A.D.
Bronze, height: 3¼ in. (8.2 cm).

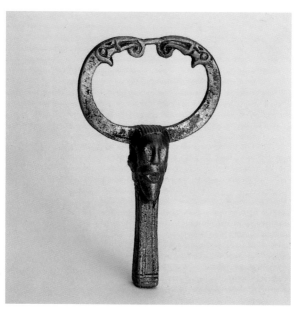

Rod with Anthropomorphic Terminal.
Northwest Russia (Ladoga), 8th century A.D.
Bronze, height: 2 in. (5.4 cm).

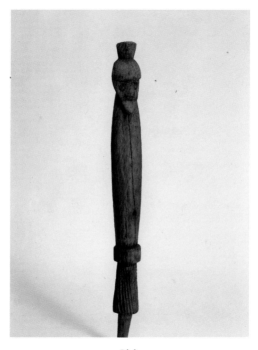

Idol.
Northwest Russia (Ladoga), 10th century A.D.
Wood, height: 10⅝ in. (27 cm).

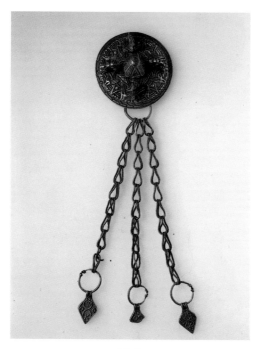

Fibula.
Western Russia (Smolensk region), 10th century A.D.
Silver, gilding, diameter of disk: 3¼ in. (8 cm).

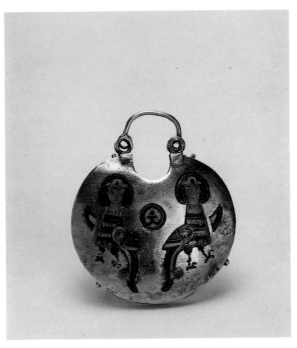

Ring Pendant.
Ukraine (Kiev), 11th–12th century A.D.
Gold, enamel, height: 2¼ in. (5.5 cm).

THE CLASSICAL WORLD

The Hermitage's collection of classical antiquities is one of the greatest in the world. Ancient Greece and Rome are represented by Greek terra-cottas; Attic, Etruscan, and South Italian vases; ancient glass; and engraved gemstones, as well as Etruscan bronzes of the sixth to the fourth century B.C. from the preeminent centers of Athens, the Peloponnese, and the islands of Aegina and Samos. One of the most notable items is a kouros of the sixth century B.C. from Samos, which has the dedicatory inscription, "Polycrates consecrated me." Classical sculptures and Roman portraits were acquired around the nucleus of Peter the Great's collection and that of John Lyde Browne, including the famous marble statue of Aphrodite known as the *Tauride Venus* (page 70), and the exquisite portrait known as *The Syrian Woman* (page 73).

The collection of some fifteen thousand painted vases includes notable examples by such craftsmen as Euphronios, Nicophenos, and Psiaxis. The terra-cottas discovered in 1884 by the Russian archaeologist P. A. Saburov in the small Boeotian town of Tanagra are justly famous. Known as the *Tanagra figurines* (pages 80 and 81), these statuettes, dating from the fourth to the third century B.C., consist mainly of painted female figures of delicate proportions.

Referring to these figurines, the French sculptor Auguste Rodin wrote of "the modest grace of a draped body and nuances that cannot be expressed in simple words."

The large collection of classical intaglios and cameos includes the third century B.C. *Gonzaga Cameo* (pages 60 and 93), with portraits of Ptolemy Philadelphus, ruler of Egypt (285–246 B.C.), and his wife, Arsinoë, which belonged to the Gonzaga dukes of Mantua in the mid-sixteenth century.

A major contribution to the Hermitage's collection of classical antiquities has come from excavations carried out since the nineteenth century in southern Russia and Ukraine. These sites include Berezan Island, the ancient towns of Olbia, Chersonesus, Panticapaeum, Phanagoria, and other settlements on the Kerch Straits in the Crimea. These towns on the northern Black Sea coast have revealed fascinating evidence of the culture that emerged as the local Scythian and Sarmatian populations intermingled with Greek colonists. Olbia, for example, was founded in the sixth century B.C. by Greeks from the Ionian town of Miletus, and soon became a center for the production of handicrafts. The variety and original ornamentation of Olbian wares (including examples of the Scythian Animal style) seem to indicate that people from local tribes, as well as Greeks, were engaged in the production of such items.

In 1830 a burial mound was discovered at Kerch in the Crimea that yielded extraordinary treasures from the

Bosporan Kingdom, which arose at the beginning of the fifth century B.C., when Greek colonial towns stretching along the shores of the Cimmerian Bosporus were united under a single ruler. The Kul Oba burial mound, as it is known, contained gold vessels depicting in relief scenes from the daily life of the Scythians, as well as exquisite Attic jewelry, such as earrings and pendants, with microscopic ornamentation.

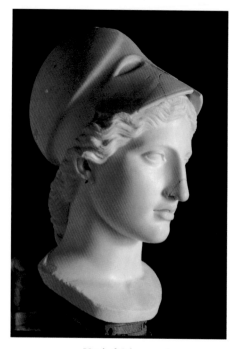

Head of Athena, n.d.
Roman copy after a Greek original of 430–420 B.C.
Marble, height: 25½ in. (65 cm).

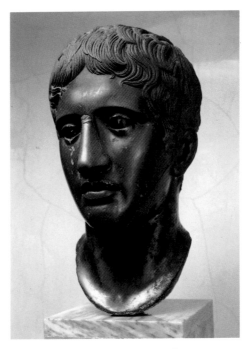

Head of Doryphorus, n.d.
Roman copy of a Greek original by Polyclitus of c. 440 B.C.
Basalt, height: 10¼ in. (26 cm).

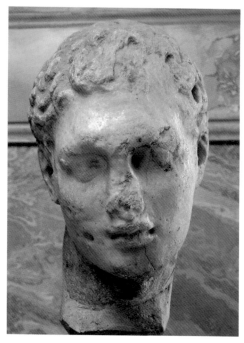

Head of a Youth.
Egypt (Alexandria?), 2d half of the 4th–3d century B.C.
Marble, height: 9½ in. (24 cm).

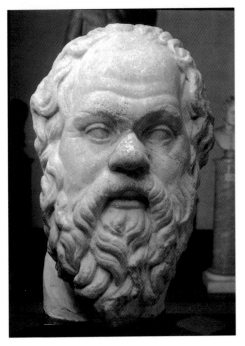

Portrait of Socrates, n.d.
Roman copy of a Greek original by Lysippus of the
4th century B.C. Marble, height: 13⅜ in. (34 cm).

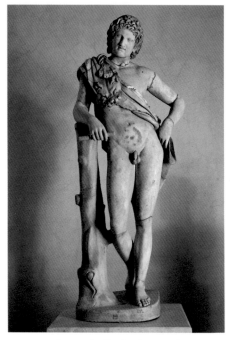

Statue of a Resting Satyr, n.d.
Roman copy of a Greek original by Praxiteles of the
4th century B.C. Marble, height: 66 in. (168 cm).

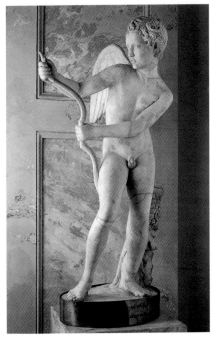

Cupid with Bow, n.d.
Roman copy of a Greek original by Lysippus of the
4th century B.C. Marble, height: 52¼ in. (133 cm).

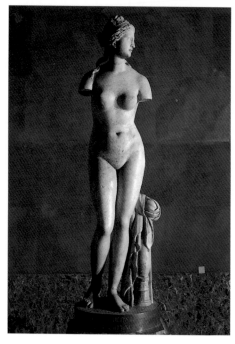

Statue of Aphrodite (Tauride Venus), n.d.
Roman copy of a Greek original of the 3d century B.C.
Marble, height: 66½ in. (169 cm).

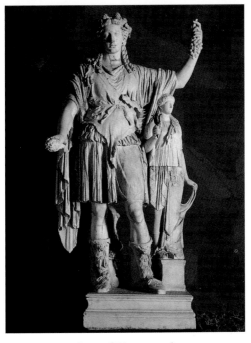

Statue of Dionysus, n.d.
Roman copy after a Greek original of the 4th century B.C.
Marble, height: 81½ in. (207 cm).

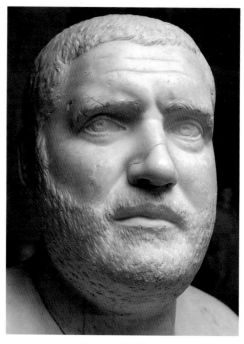

Portrait of Balbinus.
Rome, 3d century A.D.
Marble, height of head: 10¼ in. (26 cm).

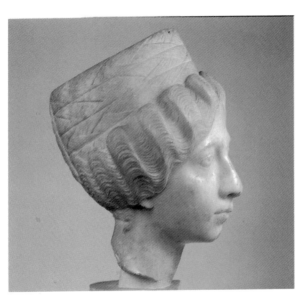

Portrait of a Woman (The Syrian Woman).
Eastern Mediterranean, A.D. 170–180.
Marble, height: 11¾ in. (30 cm).

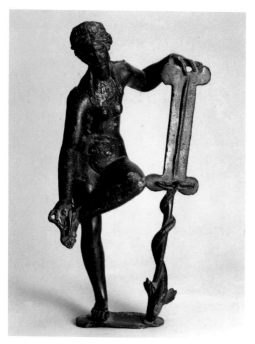

Aphrodite Tying Her Sandal, 1st century A.D.
Roman copy after a Hellenistic original of the 2d century B.C.
Bronze, height: 9 in. (22.8 cm).

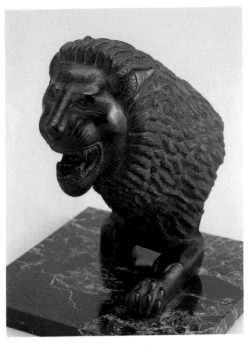

Lion's Head.
Etruria, 5th century B.C.
Bronze, height: 10¼ in. (26 cm).

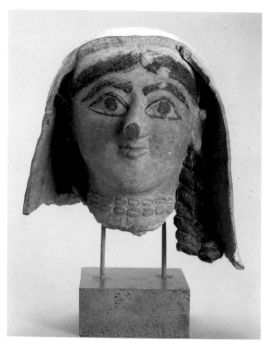

Head of a Goddess.
Cyprus, mid-6th century B.C.
Clay, height: 8½ in. (21.5 cm).

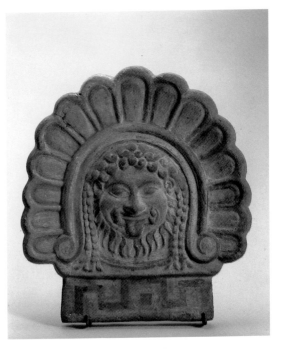

Etruscan Antefix.
Italy (Campania), 5th century B.C.
Clay, height: 14¼ in. (36 cm).

77

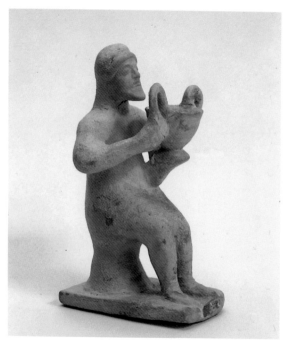

Statuette of a Man with a Cantharis.
Greece (Boeotia), late 6th–early 5th century B.C.
Clay, height: 5 in. (12.5 cm).

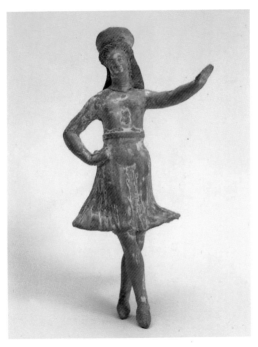

Statuette of a Girl Dancing.
Greece (Attica), 4th century B.C.
Clay, height: 6¼ in. (15.7 cm).

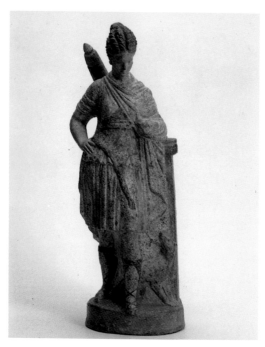

Figurine of Artemis.
Greece (Tanagra), late 4th century B.C.
Clay, height: 8⅝ in. (22 cm).

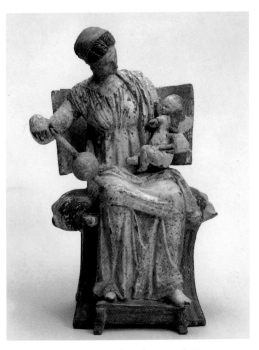

Figurine of Aphrodite Playing with Eros.
Greece (Tanagra), late 4th century B.C.
Clay, height: 7¼ in. (18.5 cm).

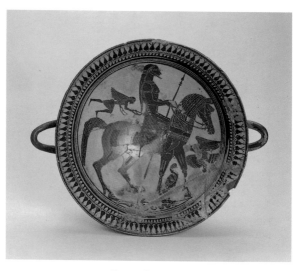

RIDER PAINTER.
Laconian Kylix. Greece (Sparta), mid–6th century B.C.
Clay, height: 5 in. (12.8 cm).

Black-Figure Dinos with Ships.
Greece (Attica), 510–500 B.C.
Clay, height: 6¾ in. (17.3 cm).

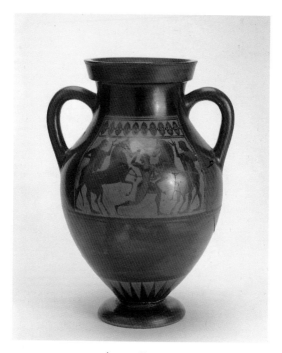

AMASIS PAINTER.
Black-Figure Amphora with a Scene of Breaking-in Horses.
Greece (Attica), 540–530 B.C. Clay, height: 12¼ in. (31 cm).

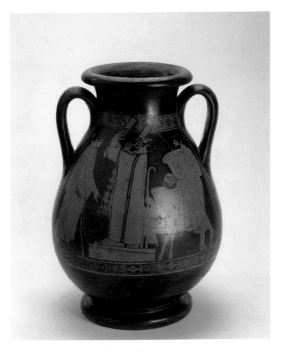

ARGOS PAINTER.
Red-Figure Pelike with Citharoedus and Listeners.
Greece (Attica), c. 480 B.C. Clay, height: 15 in. (38 cm).

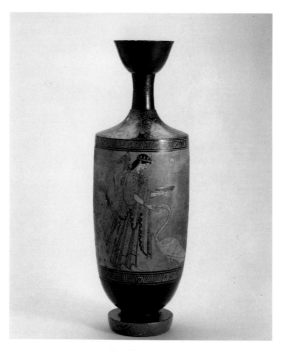

PAN PAINTER.
White-Ground Lekythos with Artemis and a Swan.
Greece (Attica), c. 490 B.C. Clay, height: 14⅞ in. (37.8 cm).

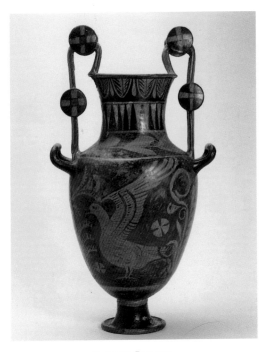

PRIMATO PAINTER.
Red-Figure Nestoris with a Bird with Raised Wing.
Italy (Lucania), 330–320 B.C. Clay, height: 21⅝ in. (55 cm).

87

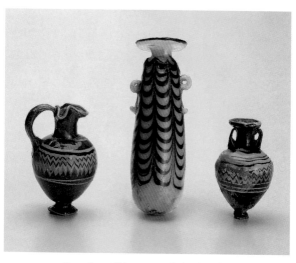

Oenochoe, Alabastron, and Amphoriskos.
Eastern Mediterranean, 6th–5th century B.C. Glass,
height: 3 in. (7.4 cm), 4⅜ in. (11.8 cm), 2½ in. (6.6 cm).

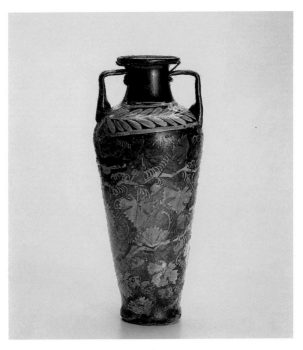

Amphora.
Egypt or Italy, 1st half of the 1st century A.D.
Glass, enamel, height: 7¾ in. (20 cm).

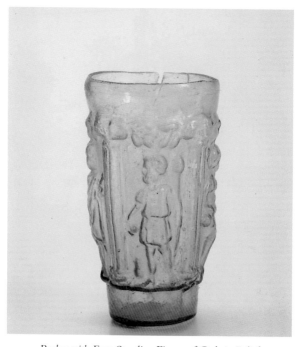

Beaker with Four Standing Figures of Gods in Relief.
Syria, late 1st century A.D.
Glass, height: 5 in. (12.5 cm).

Oenochoe.
Eastern Mediterranean, 1st century A.D.
Glass, height: 7½ in. (19 cm).

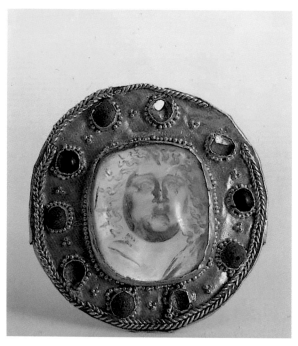

Intaglio with the Head of Helios.
Rome, 1st century A.D.
Citrine, gold, glass, height: 1 in. (2.3 cm).

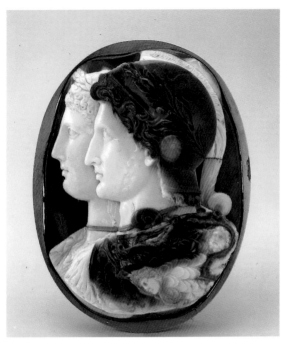

The Gonzaga Cameo.
Egypt (Alexandria), 3d century B.C.
Sardonyx, height: 6¼ in. (15.7 cm).

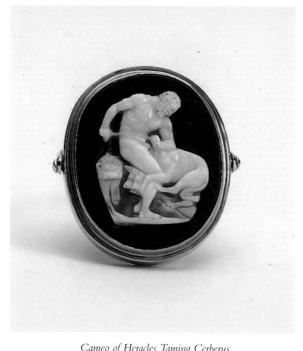

Cameo of Heracles Taming Cerberus.
Italy, 1st century B.C.–1st century A.D.
Sardonyx, height: 1.5 in. (3.8 cm).

Figure Pendants from a Necklace.
Crimea (Kerch), 3d century B.C.
Gold, length of necklace: 21¼ in. (54 cm).

Pendant with Head of Athena Parthenos.
Greece (Attica?), early 4th century B.C.
Gold, enamel, height: 7 in. (18 cm).

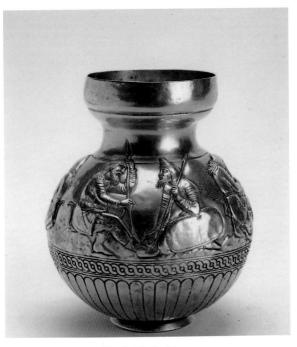

Vessel with Scythians.
Southern Russia/Crimea (?), late 4th century B.C.
Electrum, height: 5⅛ in. (13 cm).

97

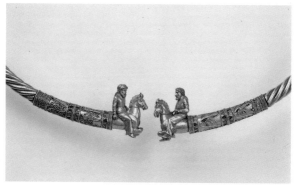

Neck Ring with Scythian Horsemen.
Southern Russia/Crimea (?), 4th century B.C.
Gold, enamel, length: 30½ in. (77.5 cm).

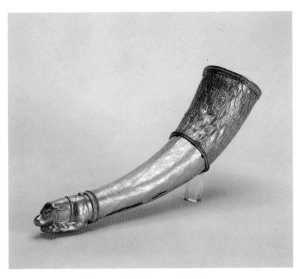

Rhyton with Protome of a Dog.
Southern Russia (Taman Peninsula), early 5th century B.C.
Gold, length: 10⅝ in. (27 cm).

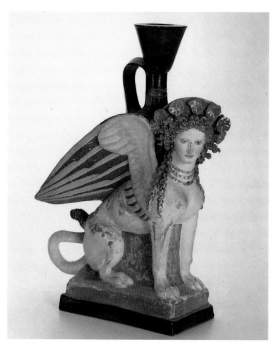

Lekythos in the Form of a Sphinx.
Greece (Attica), late 5th century B.C.
Clay, height: 8½ in. (21.5 cm).

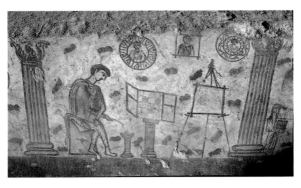

Painted Sarcophagus.
Ukraine (Bosporan Kingdom), 1st century A.D.
Limestone, width: 84½ in. (215 cm).

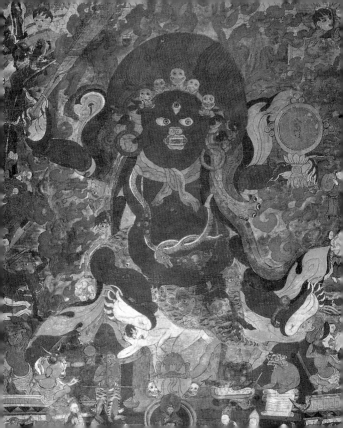

THE EAST

The Department of Oriental Culture at the Hermitage contains perhaps the widest cultural range of all the collections in the museum, from Egyptian and Coptic antiquities to Chinese New Year prints and Japanese netsuke. Many of the most interesting pieces in the collection come from within Russia's own borders and from neighboring states.

Toward the end of the nineteenth century, important discoveries were made in the region around Lake Van on the Turkish-Armenian border. Dating from the tenth to the early sixth century B.C., these items, including bronze figurines and cauldron handles in the form of bulls' heads, shed important light on the ancient state of Urartu, which ruled the region at that time.

Equally notable, the collection traditionally known as the Sassanian silver collection contains not only silver but also gold vessels fashioned by craftsmen in Iran during the reign of the Sassanid dynasty (A.D. 226–651). Most of the Sassanian vessels in the Hermitage came from treasure hoards found in Russia on both sides of the Ural Mountains; they were recognized as Sassanian because they showed kings wearing crowns similar to those seen on the coins of Sassanid rulers.

The antiquities from various cultural centers of Central Asia form a unique part of the collection. They comprise wonderfully preserved Sogdian, Persian, and Chinese clothing and textiles, as well as clay sculptures and fragments of mural paintings dating to the late first century B.C., from Hun burial mounds in the mountains of Noinula in Mongolia. Paintings and sculptures of the Xinjiang Culture, dating from the fifth to the seventh century A.D., were also discovered in the early twentieth century in the Kuchar and Turfan oases of eastern Turkestan. Further expeditions in the 1920s to Khara-khoto in Mongolia revealed treasures such as Buddhist banner paintings, or thangkas (which were carried in religious processions and used to illustrate sermons), dating from the twelfth century A.D., when Central Asia was dominated by the Tangut state of Xi-Xia.

In 1900, a chance find of treasures in a walled-up cave near the northern Chinese town of Dunhuang sparked intense interest from scholars around the world. Known as the Cave of a Thousand Buddhas, the site is an ancient monastery consisting of a row of caves carved into the cliff above a river valley. In 1914–15 the Russian archaeologist S. F. Oldenburg carefully selected objects from the caves that he considered to be at risk, and returned to Russia with fragments of wall paintings, sculptures, votive banners, and items of silk, linen, and paper.

Dating from the seventh to the ninth century A.D., these treasures from Dunhuang provide a valuable insight into an art unique to Chinese Buddhism.

Since 1947, excavations and research at the Tadjik town of Pendjikent, the ancient capital of a small Sogdian principality that flourished from the sixth to the eighth century A.D., have revealed mural paintings and wooden figurines of female dancers that are of great artistic and iconographic interest. The museum also contains a wide range of artifacts (paintings, sculptures, costumes, jewelry, ceramics, and weaponry) from the other Asiatic regions, including India, Japan, Indonesia, and Turkey.

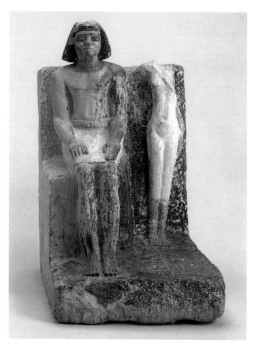

Funerary Sculpture of Udjankhdjes with His Wife.
Egypt, 27th–26th century B.C.
Painted limestone, height: 15 in. (38 cm).

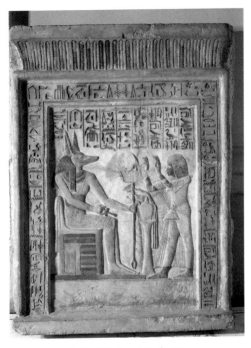

Stele of the Royal Scribe Ipi.
Egypt (Saqqara), mid–14th century B.C.
Painted limestone, 37⅜ x 28 in. (95 x 71 cm).

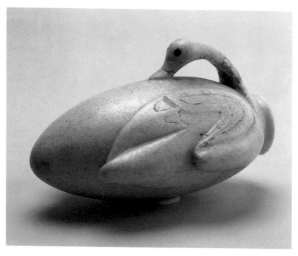

Vessel in the Shape of a Duck.
Egypt, c. 2100–1780 B.C.
Alabaster, height: 8¾ in. (22.4 cm).

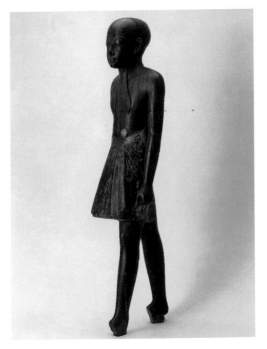

Figurine of a Youth.
Egypt (Thebes), late 15th century B.C.
Wood, height: 13½ in. (34.5 cm).

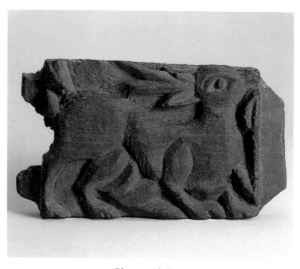

Plaque with Deer.
Egypt, 6th–7th century A.D.
Wood, length: 6⅝ in. (16.8 cm).

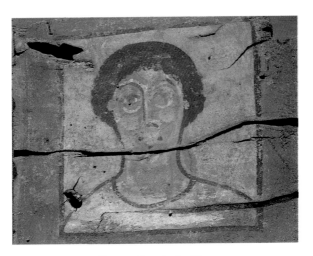

Funerary Portrait of a Man.
Egypt (Faiyum?), 4th–5th century A.D.
Wood, tempera, 11¼ x 9⅝ in. (28.5 x 24.5 cm).

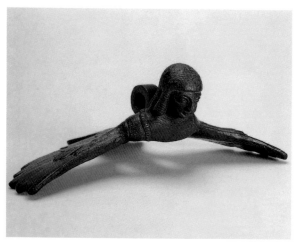

Handle from a Cauldron in the Shape of a Winged Figure with a Female Torso. Turkey/Armenia (Urartu), 8th century B.C. Bronze, width: 9½ in. (24 cm).

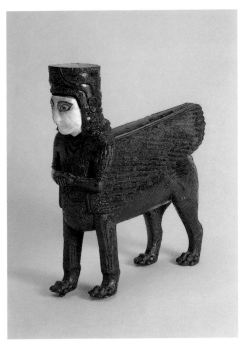

Figure Decorating a Throne.
Turkey/Armenia (Urartu), 8th century B.C.
Bronze, stone, height: 6¼ in. (16 cm).

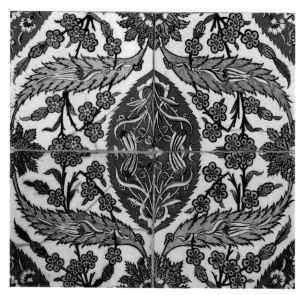

Tile Panel.
Turkey, 2d half of the 16th century A.D.
Faience, 21½ x 20 in. (54.5 x 51 cm).

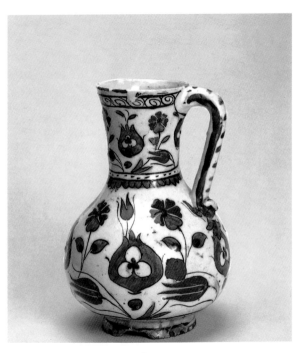

Jug.
Turkey (Iznik), late 16th–early 17th century A.D.
Faience, height: 6⅞ in. (17.4 cm).

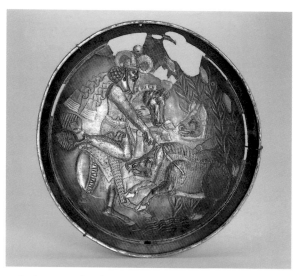

Dish Decorated with a Scene of Prince Varahran Out Hunting.
Eastern Iran, 2d half of the 4th century A.D.
Silver, gilding, diameter: 11 in. (28 cm).

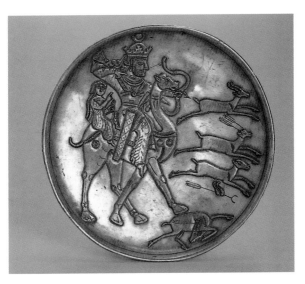

Dish Decorated with the Figures of Bahram Gur and Azade.
Iran (?), 7th century A.D.
Silver, gilding, diameter: 8½ in. (21.7 cm).

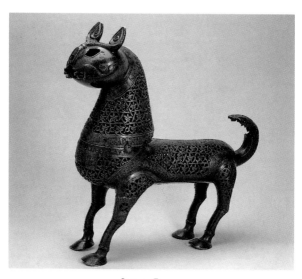

Incense Burner.
Iran, 11th century A.D.
Bronze, copper, silver, height: 17¾ in. (45 cm).

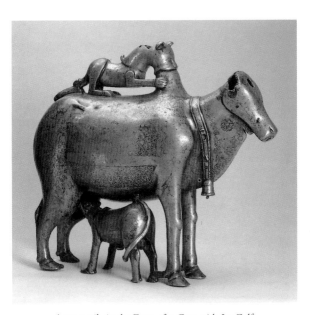

Aquamanile in the Form of a Cow with Its Calf.
Iran, 1206.
Bronze, silver, height: 13¾ in. (35 cm).

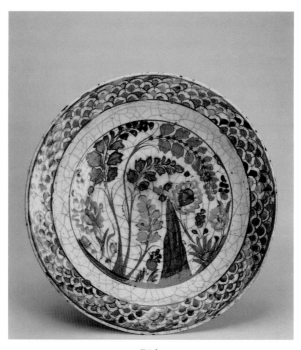

Dish.
Iran, 17th century A.D.
Fritware, diameter: 13 in. (33 cm).

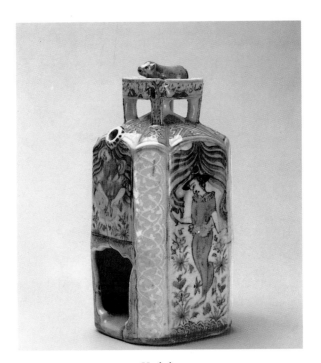

Hookah.
Iran, early 18th century A.D.
Fritware, height: 9½ in. (24 cm).

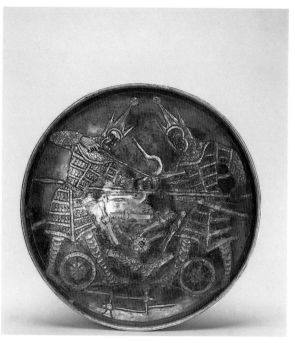

Dish with a Duel Scene.
Central Asia (Sogdia), 7th century A.D.
Silver, diameter: 8½ in. (21.8 cm).

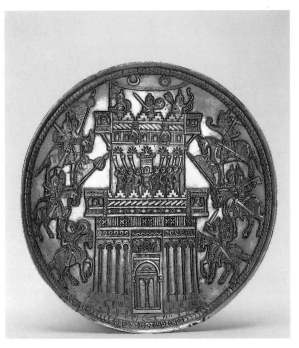

Dish with a Besieged Fortress.
Central Asia (Sogdia), 9th–10th century A.D.
Silver, diameter: 9⅜ in. (23.7 cm).

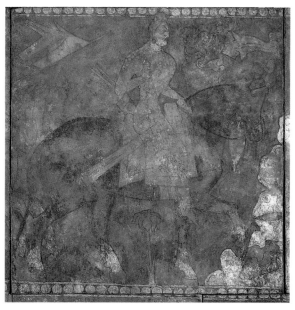

Wall Painting (The Heroic Rustam).
Central Asia (Pendjikent), 1st half of the 8th century A.D.
Painted plaster, height: 39⅜ in. (100 cm).

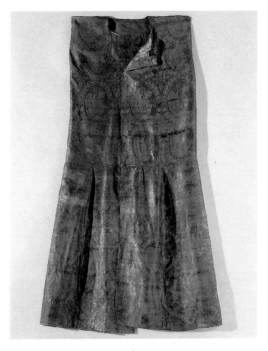

Caftan.
Northwest Caucasus, 9th century A.D.
Silk, length: 55 in. (140 cm).

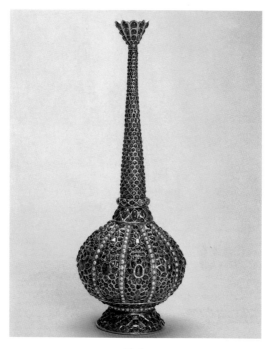

Flask.
India, 17th century A.D.
Gold, silver, precious stones, height: 11⅜ in. (28.8 cm).

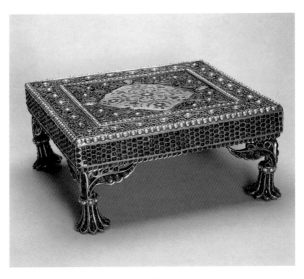

Table/Stand.
India, 17th century A.D. Gold, precious stones, pearls,
enamel, 9⅜ x 9⅜ x 4 in. (23.7 x 23.7 x 10 cm).

127

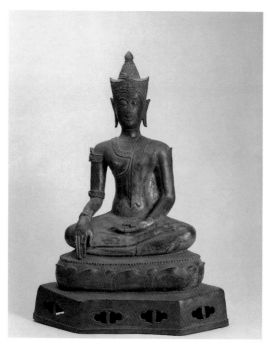

Crowned Buddha.
Thailand, late 15th–early 16th century A.D.
Bronze, gilding, height: 22 in. (56 cm).

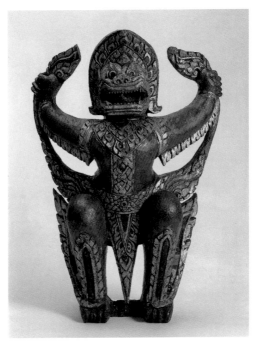

Small Figure of a Demon.
Thailand, 19th century A.D. Wood, red lacquer,
inlays of colored mirrors, height: 18⅛ in. (46 cm).

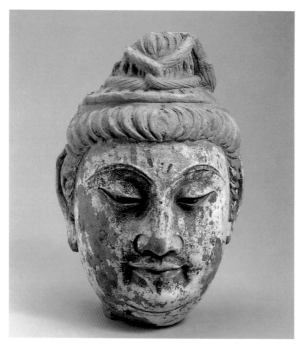

Head of a Bodhisattva.
China (Dunhuang), 8th century A.D.
Clay, color wash, height: 7½ in. (19 cm).

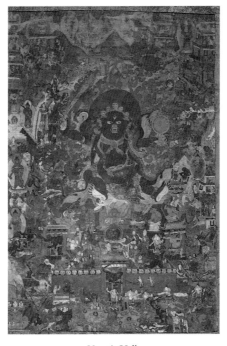

Yama's Hell.
Tibet, 17th–18th century A.D.
Color wash on canvas, 52 x 29⅛ in. (132 x 74 cm).

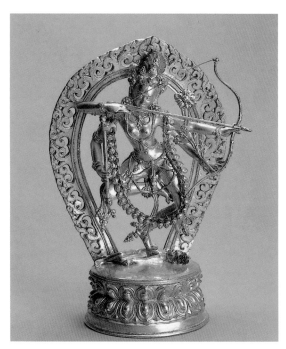

Kurukulla.
Mongolia (?), late 17th–early 18th century A.D.
Brass, gilding, turquoise, height: 5½ in. (14 cm).

Thangka (A Siddha and Dakini).
Mongolia (Khara-khoto), 12th century A.D.
Gouache on cotton, 3⅛ x 3 in. (8 x 7.5 cm).

Wall Painting (Self-Portrait of a Painter).
Mongolia (Bezeklik), 9th–10th century A.D.
Painted plaster, 10¼ x 7 in. (26 x 18 cm).

Wall Painting (Garuda).
Mongolia (Bezeklik), 9th–10th century A.D.
Painted plaster, 13⅜ x 18⅞ in. (34 x 48 cm).

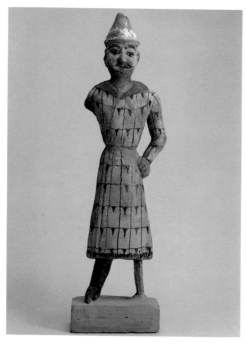

Funerary Figurine of a Foreign Merchant.
Eastern Turkestan (Xinjiang Culture), 7th century A.D.
Painted clay, height: 17 in. (43 cm).

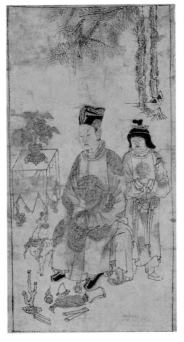

Official with a Servant.
Mongolia (Khara-khoto), 12th century A.D.
Ink on paper, 9⅞ x 7⅞ in. (25 x 20 cm).

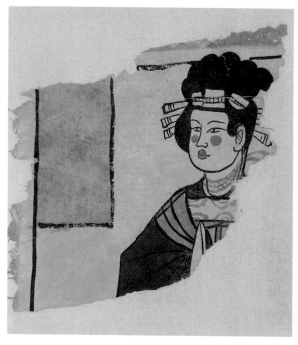

Fragment Showing Woman Donor.
China (Dunhuang), 9th century A.D.
Ink on paper, 8½ x 7½ in. (21.5 x 19 cm).

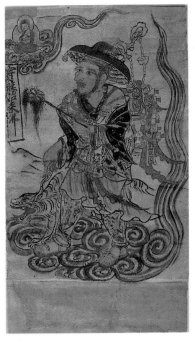

Old Man with a Fly Whisk.
China (Dunhuang), 10th century A.D.
Ink on paper, 20⅜ x 11¾ in. (51.8 x 29.8 cm).

Needlework Basket.
China, late 18th–early 19th century A.D.
Ivory, height: 18 in. (45.5 cm).

Flask.
China, 18th century A.D. Porcelain,
polychrome painting over glaze, height: 10¼ in. (26 cm).

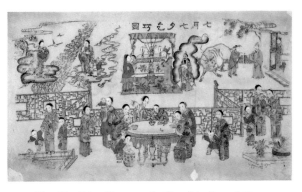

New Year Print (Prayer on the Eve of the Seventh Day of the Seventh Month). China, early 20th century A.D. Paint on paper, 24½ x 42⅛ in. (62 x 107 cm).

TSU SCHOOL.
Netsuke Depicting Yu Zhan. Japan,
late 18th–early 19th century A.D. Wood, height: 1⅛ in. (3 cm).

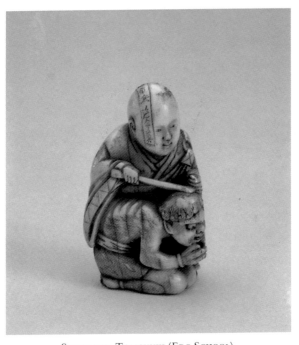

SHOKYUSAI TOMOYUKI (EDO SCHOOL).
Netsuke Showing the Shaving of a Demon in the Guise of a Monk.
Japan, 2d half of the 19th century A.D.
Ivory, height: 1¾ in. (4.6 cm).

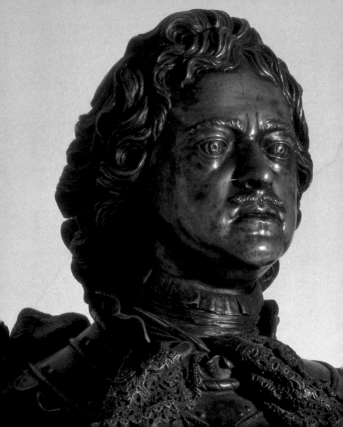

RUSSIA

The Hermitage collection of ancient Russian artifacts, painting, and sculpture, as well as decorative and applied arts, were only united in one department in 1941, but since then the Department of Russian Culture has expanded rapidly, now holding some 332,000 items.

Since the 1950s, Russian archaeologists have acquired for the Hermitage fragments of frescoes and wall paintings from churches in Russia's ancient cities—Kiev, Smolensk, Pskov, and Novgorod—which have been restored by the museum. Within the kremlin of Pskov, for example, the archaeologist V. D. Beletsky unearthed the remains of frescoes from the ruins of several churches. One of them, the Church of St. Nicholas with the Oars, yielded late fourteenth-century frescoes such as the *Head of an Unknown Saint* (page 150), a characteristic example of the Pskov School, which combines a free style with icon-painting traditions. The collection of some twelve hundred early Russian icons, painted in the thirteenth and fourteenth century, includes wonderful examples of the Novgorod, Pskov, Moscow, and Yaroslav schools, such as the "red-ground" *St. Nicholas* of the Novgorod School (page 152).

In addition to icons and wall paintings, the Hermitage also has a notable collection of applied arts from medieval Russia, consisting of objects made of bone, wood, stone,

metal, clay, glass, and leather. This collection includes a shroud depicting St. Silvester that provides a rare example of raised embroidery and incorporates the date 1664 (page 155). Other items of decorative and applied art of the seventeenth century include gold, silver, and copper caskets, as well as salt-cellars, cups, and flasks decorated with painted enamel.

The collection of Russian paintings comprises some three thousand works by Russia's leading artists of the eighteenth and nineteenth century, among them Alexei Petrovich Antropov, Ivan Nikitich Nikitin, Andrei Matveyev, F. S. Rokotov, Dmitri Grigorievich Levitsky, Karl Palovich Bryullov, Stepan Semyonovich Shchukin, and I. N. Kramskoi. The Russian mosaic collection, dating from the mid-eighteenth to the early twentieth century, includes mosaics by M. V. Lomonosov and his workshop and miniature mosaics by Y. Y. Vekler, such as his *View from the River Neva* (page 167).

The collection of eighteenth- and nineteenth-century Russian watercolors and drawings comprises town-scapes, especially views of St. Petersburg and its environs; numerous portraits; and architectural drawings that show the development of Russian architecture in the second half of the eighteenth century. The wide range of prints and engravings includes lithographic portraits of the Decembrists, shortly before their 1825 uprising.

Articles fashioned from precious metals are richly

represented in the Hermitage's Russian collection. Spanning the period from the twelfth to the twentieth century, the collection contains works by master craftsmen from St. Petersburg, Moscow, Novgorod, and Solvychegodsk, as well as from the Siberian towns of Tobolsk and Irkutsk. Items produced by the leading craftsmen of the Fabergé workshop in St. Petersburg around the turn of the twentieth century show Fabergé's magnificent command of jewelry techniques, especially in the use of transparent enamels and articles wrought from semi-precious stones (page 174).

Of the five hundred existing works of art fashioned in steel by the armorers of Tula, south of Moscow, three hundred are in the Hermitage collection. In the eighteenth and early nineteenth century, the craftsmen of Tula cut steel into diamond facets, colored the surface, and inlaid it with nonferrous metals, so that the facets sparkled like precious stones. Furniture was also produced at Tula, such as a folding armchair of the 1740s commissioned by Empress Elizabeth.

An interesting footnote to the artifacts kept in the Russian Department is the unique collection of scientific instruments acquired by Peter the Great in the early eighteenth century, here represented by a surveyor's astrolabe of 1721 (page 189) and a sundial made by the British craftsman John Rowley in 1714–19 (page 188).

PSKOV SCHOOL.
Head of an Unknown Saint, late 14th century.
Fresco, 7 x 6⅛ in. (18 x 15.5 cm).

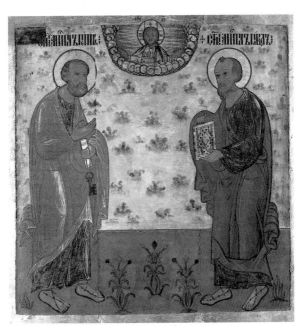

FEOKTIST KLIMENTOV (NORTHERN SCHOOL).
Apostles Peter and Paul, 1708. Egg tempera on gesso,
linen, wood, 32¼ x 32½ in. (82 x 82.5 cm).

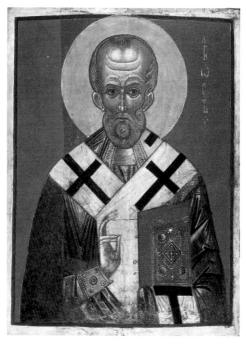

Novgorod School.
St. Nicholas, late 13th–early 14th century. Egg tempera
on gesso, linen, wood, 42⅜ x 31¼ in. (107.7 x 79.5 cm).

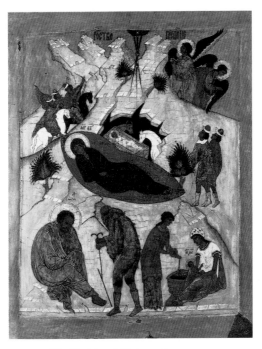

The Nativity of Christ, 16th century.
Egg tempera on gesso, linen, wood,
22 x 17½ in. (56 x 44.5 cm).

Link from a Diadem, 12th century.
Gold, cloisonné,
1⅞ x 1⅛ in. (4.6 x 2.9 cm).

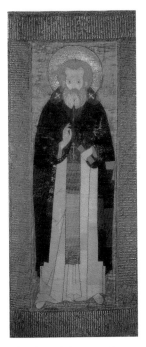

Shroud with St. Silvester, 17th century.
Embroidery with silk thread on damask, satin, canvas,
75½ x 32⅝ in. (192 x 83 cm).

PHILIPPE BÉHAGLE and IVAN KOBYLYAKOV.
The Battle of Poltava, 1722.
Wool, silk (tapestry), 118 x 124 in. (300 x 315 cm).

Company Banner of the Preobrazhensky Regiment of Life-Guards, 1700. Silk, appliqué and painted decoration, 114⅛ x 118 in. (290 x 300 cm).

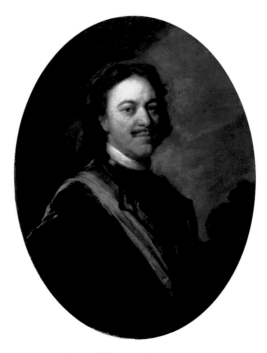

Andrei Matveyev (1701–1739).
Portrait of Peter I, after 1725.
Oil on canvas, 30¾ x 24 in. (78 x 61 cm).

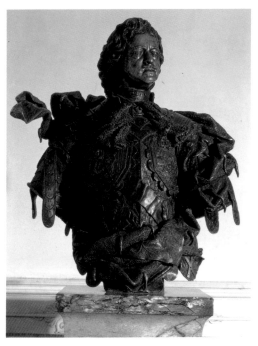

BARTOLOMEO CARLO RASTRELLI (1675–1744).
Portrait Bust of Peter I, 1723–29.
Bronze, height: 40 in. (102 cm).

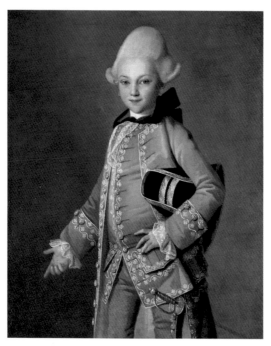

CARL LUDWIG CHRISTINEK (1730/32–1794?).
Portrait of Count Bobrinsky as a Child, 1769.
Oil on canvas, 35½ x 28⅞ in. (90 x 73.5 cm).

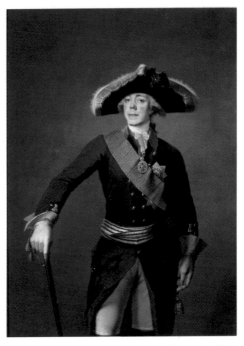

STEPAN SEMYONOVICH SHCHUKIN (1762–1828).
Portrait of Paul I, 1796–97.
Oil on canvas, 60⅝ x 45⅝ in. (154 x 116 cm).

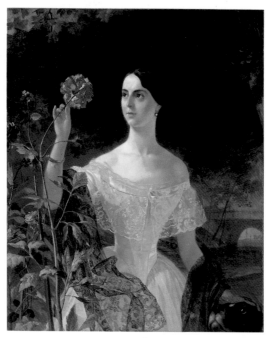

KARL PAVLOVICH BRYULLOV (1799–1852).
Portrait of Sofia Shuvalova, 1849.
Oil on canvas, 40⅛ x 33¼ in. (102 x 84.5 cm).

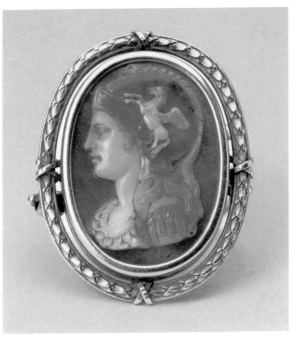

KARL LEBERECHT (1755–1827).
*Cameo of the Head of Minerva, Wearing a Helmet Decorated
with a Depiction of Pegasus,* late 18th–early 19th century.
Cornelian, gold, 1⅜ x 1⅛ in. (3.5 x 2.8 cm). 163

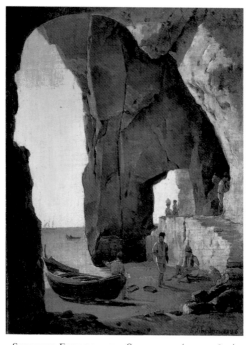

SILVESTER FEODOSIEVICH SHCHEDRIN (1791–1830).
Cave in Sorrento, 1826.
Oil on canvas, 10 x 7½ in. (25.4 x 19 cm).

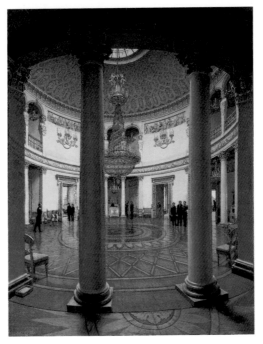

YEFIM TUKHARINOV (active 1st half of 19th century).
Interior of the Rotunda in the Winter Palace, 1834.
Oil on canvas, 41 x 31⅞ in. (104 x 81 cm).

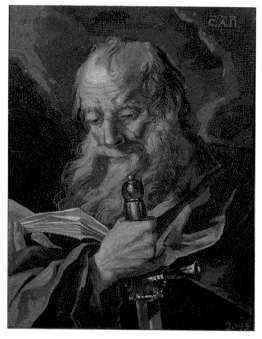

MATVEI VASILIEVICH VASILIEV (c. 1732–1786).
The Apostle Paul, 1769.
Smalto mosaic on a copper base, 20½ x 16⅛ in. (52 x 41 cm).

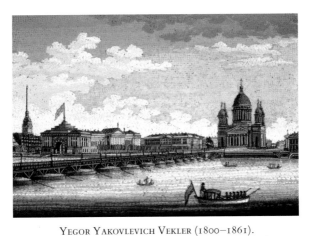

YEGOR YAKOVLEVICH VEKLER (1800–1861).
*View from the River Neva over St. Isaac's Square and
St. Isaac's Bridge in St. Petersburg,* 1840.
Smalto and Roman mosaic, metal, 3 x 4¼ in. (7.6 x 10.7 cm). 167

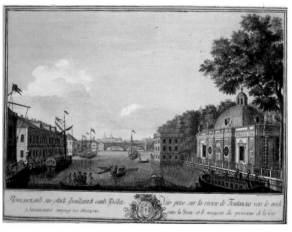

GRIGORY ANIKIEVICH KACHALOV (1711/12–1759).
View of the Fontanka River from the Grotto and the Guest Palace
in St. Petersburg, 1753. Etching with engraving,
19½ x 27⅛ in. (49.7 x 69 cm).

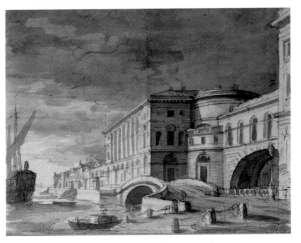

PIETRO GONZAGA (1751–1831).
*View of the Neva Embankment with the Hermitage Theater
in the Foreground,* after 1802. Pen, brush, India ink,
pencil, 10 x 13⅜ in. (25.5 x 34 cm).

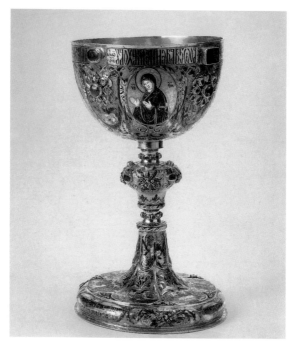

Chalice, 1677.
Gold, enamel, niello, precious stones,
height: 11½ in. (29.2 cm).

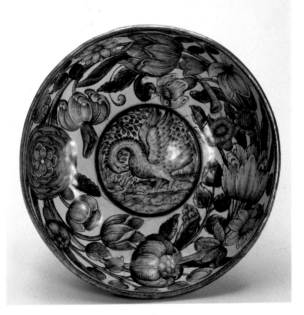

Cup, late 17th century.
Silver, filigree, painted enamel,
diameter: 5¾ in. (14.5 cm).

YAKOV SEMYONOVICH MASLENNIKOV.
Kovsh, 1761.
Silver gilt, 4⅜ x 11⅞ x 6½ in. (11 x 30 x 16.5 cm).

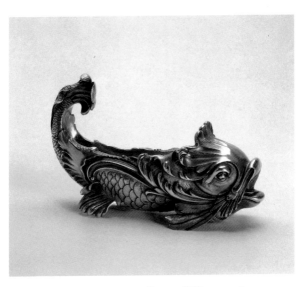

JULIUS RAPPOPORT (FABERGÉ WORKSHOP).
Ashtray in the Shape of a Fish, late 19th century.
Silver gilt, 3⅝ x 5¾ x 2⅜ in. (8.7 x 14.7 x 5.9 cm).

173

FABERGÉ WORKSHOP.
A Narcissus and a Bilberry Twig in Small Vases, 1880s.
Nephrite, cacholong, lapis lazuli, diamond, enamel,
174 rock crystal, gold, height: 10⅝ in. (27 cm), 5½ in. (14.2 cm).

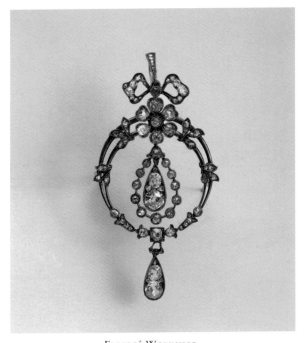

FABERGÉ WORKSHOP.
Pendant Brooch, late 19th–early 20th century.
Gold, diamonds, 2¼ x 1⅛ in. (5.8 x 3 cm).

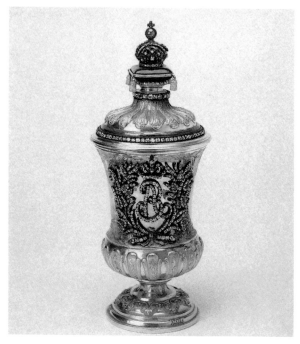

Covered Cup, late 18th century.
Gold, silver, diamonds, ruby, enamel,
height with lid: 8⅛ in. (20.7 cm).

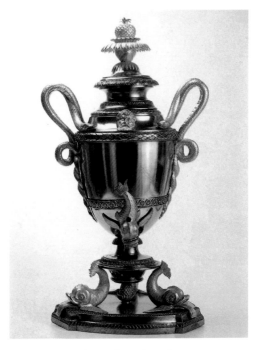

Samovar, late 18th–early 19th century.
Steel, cast iron, and bronze, heat treated and gilt,
25½ x 14½ x 13⅜ in. (65 x 37 x 34 cm).

Vase, 1820s.
Porcelain, polychrome overglaze decoration, gilding,
engraved with agate pencil, height: 15¼ in. (38.6 cm).

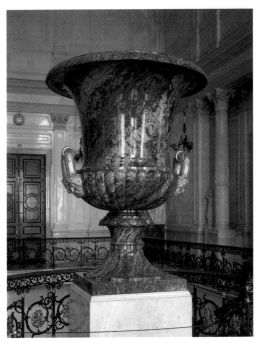

Medici Vase, 1839–42.
Malachite, gilded bronze,
height: 71⅝ in. (182 cm).

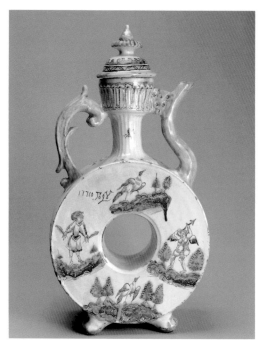

Kvas Jug with Lid, 1770.
Majolica, polychrome enamel on wet glaze,
height: 18¾ in. (47.5 cm).

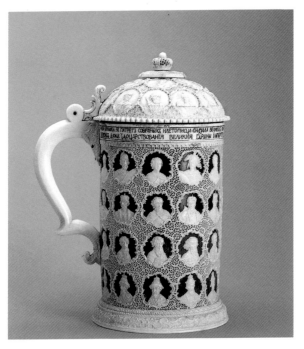

OSIP KHRISTOFOROVICH DUDIN (1714–1780).
Tankard, 1770s. Bone with tinted background, silver, gilding,
9⅞ x 7 x 5⅛ in. (25 x 18 x 13 cm).

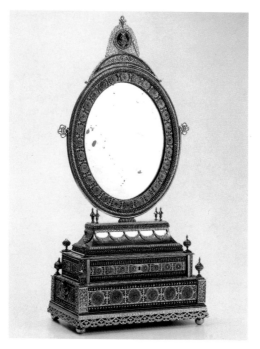

Dressing-Table Set, c. 1801.
Steel and bronze, heat treated, faceted, chased, and gilt,
27½ x 12½ x 7 in. (70 x 32 x 18 cm).

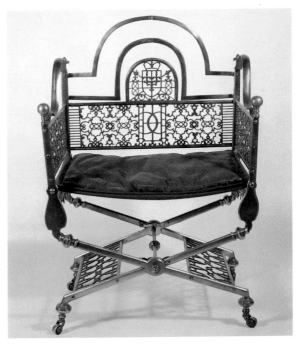

Folding Armchair, 1740s.
Steel and brass, heat treated and cut,
42⅛ x 27 x 17¾ in. (107 x 68.5 x 45 cm).

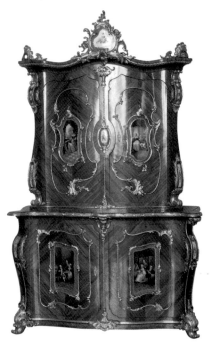

GAVRIL ALEXANDER.
Cabinet, 1846. Rosewood, bronze, porcelain,
painted decoration, 73¼ x 55½ x 24 in. (186 x 141 x 61 cm).

HEINRICH GAMBS (1765–1831).
Bureau, 1795–1815. Mahogany, ormolu,
68⅞ x 68⅞ x 37⅜ in. (175 x 175 x 95 cm).

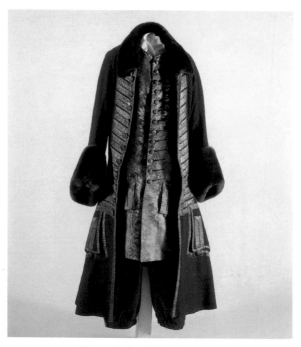

Winter Outfit of Peter I, 1710–20.
Woolen cloth and silk fabric, galloon, beaver fur,
length: 49¼ in. (125 cm).

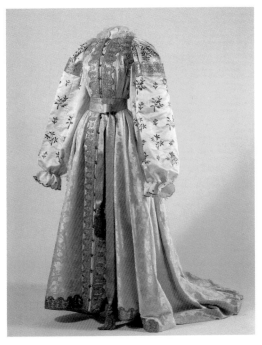

Cossack Woman's Wedding Dress, end of the 19th century.
Figured silk, white satin, gold embroidery,
length with train: 52 in. (132 cm).

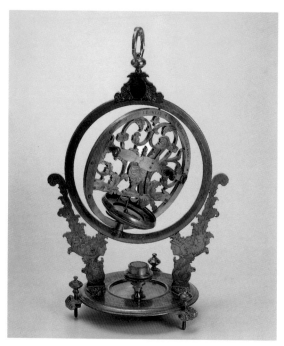

JOHN ROWLEY (1674–1719).
Sundial, 1714–19. Bronze, steel, glass, silver plating,
8¾ x 8½ x 17⅜ in. (22.2 x 21.8 x 44.2 cm).

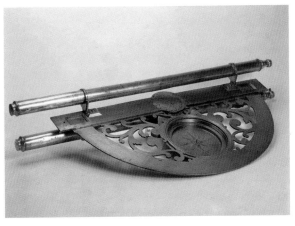

EDMUND CULPEPER (1680–1740).
Surveyor's Astrolabe, 1721.
Brass, steel, glass, 25⅛ x 9¾ in. (63.8 x 24.8 cm).

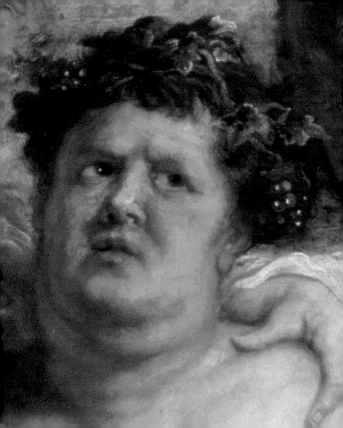

THE WEST

In 1769 Catherine the Great purchased six hundred Flemish, Dutch, and French paintings from the von Brühl collection in Berlin, and had them brought to St. Petersburg for her nascent art gallery in the Winter Palace. So began a collection of Western European painting that today numbers some five thousand works from every major school and movement, including many of the greatest masterpieces in the world.

In 1772 the Hermitage acquired Pierre Crozat's collection, one of the most important European art collections of the eighteenth century. Thus Titian's *Danaë*, Raphael's *Holy Family* (page 200), Giorgione's *Judith*, wrongly attributed until the end of the nineteenth century to Raphael (page 212), and Rubens's *Bacchus* (opposite and page 221), entered the museum. For more than a century thereafter other important collections were purchased, making the Hermitage one of the world's most comprehensive repositories of Western European art. The Venetian works, for example, are so extensive (comprising more than three hundred of the museum's 1,091 Italian paintings) that it is possible to trace the entire history of Venetian painting, from its conception and development in the fourteenth century to the Renaissance (with

works by Cima da Conegliano, Giorgione, Palma Vecchio, Titian, Veronese, and Tintoretto) and then to its revival in the eighteenth century (with Guardi, Canaletto, and the last great Venetian painter, Tiepolo).

Of the ten or twelve paintings by Leonardo known to exist, two—the *Benois Madonna* and the *Madonna Litta* —are in the Hermitage (pages 198 and 199); the eight canvases by Titian in the collection include *The Rest on the Flight into Egypt,* dating from Titian's little-known early period, and *St. Sebastian* (page 205), the innovative style of which opened unprecedented perspectives for European art.

The collection of Spanish painting includes *The Apostles Peter and Paul* by El Greco (page 215), who heralded the Golden Age of Spanish painting in the seventeenth century, which is represented in the museum by a constellation of great painters: Ribera, Zurbarán, Velásquez, and Murillo. The collections of Netherlandish and Dutch painting are equally rich. Most notable are twenty-six paintings by Rembrandt from various periods, including his spiritual revelation *The Return of the Prodigal Son* (page 223). Rubens, Van Dyck, Jordaens, and Teniers the Younger, among others, bear witness to the remarkable quality of the Flemish canvases in the Hermitage. And while seventeenth century France is represented by the Le Nain brothers (including Louis Le Nain's wonderful *The Dairy-*

maid's Family [page 226]), Poussin, and Claude, it is eighteenth-century artists such as Watteau, Boucher, Fragonard, Chardin, Greuze, and Joseph Robert who predominate.

The collection of Western European sculpture in the Hermitage includes one of the few original works by Michelangelo outside of Italy—the *Crouching Boy* (page 209)—as well as works by such masters as Canova (*Cupid and Psyche,* page 208) and Houdon (*Voltaire,* page 229). The museum's collection of drawings numbers some forty thousand works, including preliminary sketches, portraits, and architectural drawings in a wide range of media, by many of the greatest Italian, French, Dutch, Flemish, and German artists from the sixteenth to the twentieth century.

The applied and decorative art collection, including tapestries, textiles, furniture, mosaics, glassware, cameos, and jewelry is equally comprehensive. The fifteen thousand pieces of European porcelain, including items from Meissen and Sèvres, and the famous Wedgwood Green Frog service are especially noteworthy, as is Anton Basilevsky's Parisian collection of medieval applied art, comprising primarily ecclesiastical objects.

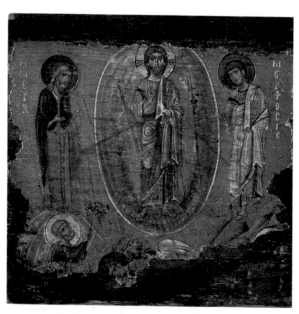

The Transfiguration. Byzantine, 12th century.
Wood, gesso, egg tempera,
9⅛ x 9⅜ in. (23.2 x 23.7 cm).

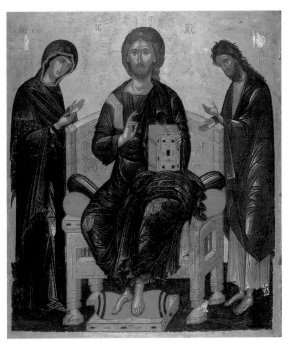

Deesis. Byzantine, 16th century.
Wood, gesso, egg tempera,
27⅛ x 24 in. (69 x 61 cm).

ANDREA DI VANNI (C. 1332–C. 1414).
The Ascension of Christ, 1355–60.
Tempera on panel, 26¾ x 11 in. (68 x 28 cm).

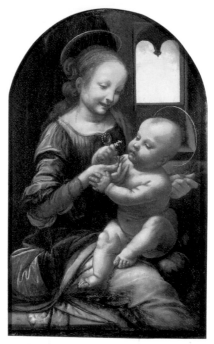

LEONARDO DA VINCI (1452–1519).
Madonna with a Flower (Benois Madonna), 1478–80.
Oil on canvas, 19½ x 13 in. (49.5 x 33 cm).

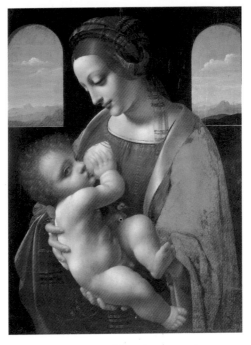

LEONARDO DA VINCI (1452–1519).
Madonna and Child (Madonna Litta), 1490–91.
Tempera on canvas, 16½ x 13 in. (42 x 33 cm).

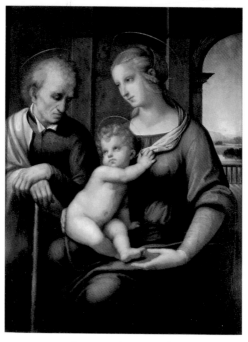

RAPHAEL (1483–1520).
The Holy Family (Madonna with the Beardless Joseph), c. 1506.
Tempera and oil on canvas, 28½ x 22¼ in. (72.5 x 56.5 cm).

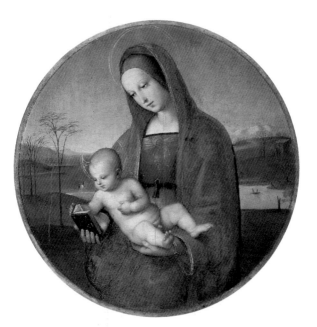

RAPHAEL (1483–1520).
Madonna and Child (Conestabile Madonna), c. 1504.
Tempera on canvas, 6⅞ x 7 in. (17.5 x 18 cm).

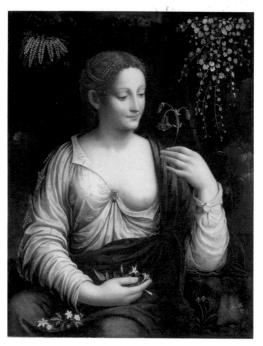

FRANCESCO MELZI (1493–c. 1570).
Flora, c. 1520.
Oil on canvas, 30 x 24¾ in. (76 x 63 cm).

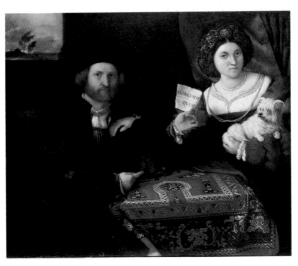

LORENZO LOTTO (c. 1480–1556).
Husband and Wife, c. 1523.
Oil on canvas, 37¾ x 45⅝ in. (96 x 116 cm).

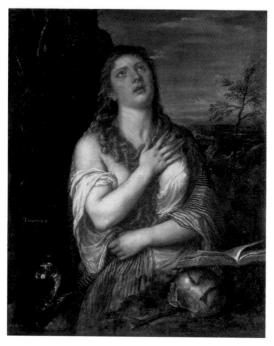

TITIAN (1488/90–1576).
Mary Magdalene in Penitence, 1560s.
Oil on canvas, 46½ x 38⅛ in. (118 x 97 cm).

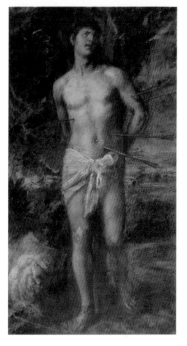

TITIAN (1488/90–1576).
St. Sebastian, 1570s.
Oil on canvas, 82⅝ x 45½ in. (210 x 115.5 cm).

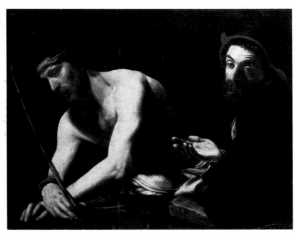

GIOVANNI BATTISTA CARACCIOLO (c. 1575–1635).
Christ before Caiaphas, c. 1615.
Oil on canvas, 30¾ x 41 in. (78 x 104 cm).

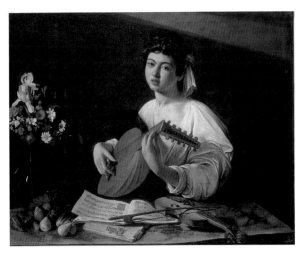

CARAVAGGIO (1571–1610).
The Lute Player, c. 1596.
Oil on canvas, 37 x 46⅞ in. (94 x 119 cm).

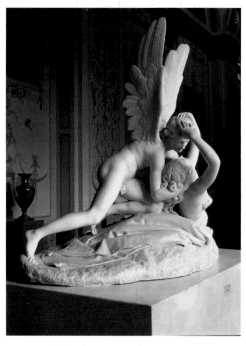

ANTONIO CANOVA (1757–1822).
Cupid and Psyche, 1796.
Marble, height: 54 in. (137 cm).

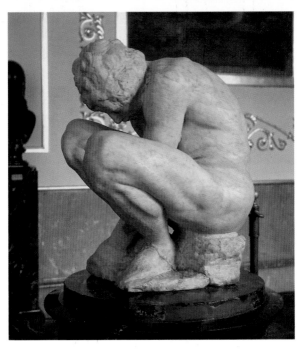

MICHELANGELO BUONARROTI (1475–1564).
Crouching Boy, c. 1530–34.
Marble, height: 21¼ in. (54 cm).

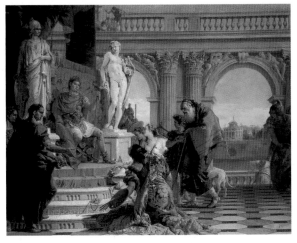

GIOVANNI BATTISTA TIEPOLO (1696–1770).
Maecenas Presenting the Liberal Arts to Emperor Augustus, 1743.
Oil on canvas, 27⅜ x 35 in. (69.5 x 89 cm).

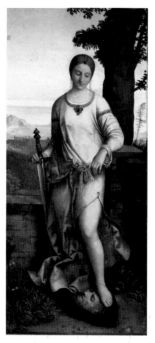

GIORGIONE (1477–1510).
Judith, after 1504.
Oil on canvas, 56⅝ x 26¾ in. (144 x 68 cm).

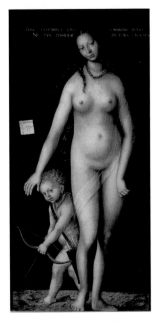

LUCAS CRANACH THE ELDER (1472–1553).
Venus and Cupid, 1509.
Oil on canvas, 83¾ x 40⅛ in. (213 x 102 cm).

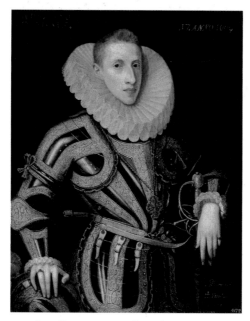

JUAN PANTOJA DE LA CRUZ (1553–1608).
Portrait of Don Diego de Villamaior, 1605.
Oil on canvas, 34⅞ x 27¾ in. (88.5 x 70.5 cm).

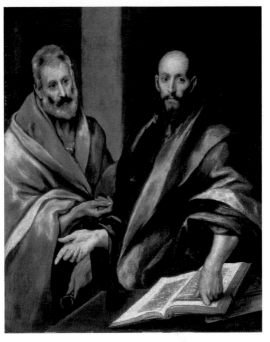

EL GRECO (1541–1614).
The Apostles Peter and Paul, 1587–92.
Oil on canvas, 47⅝ x 41⅜ (121 x 105 cm).

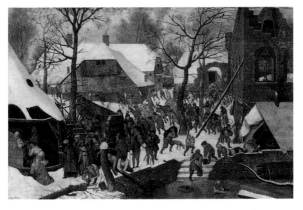

PIETER BRUEGHEL THE YOUNGER (c. 1564–1638).
The Adoration of the Magi, n.d.
Oil on canvas, 14⅛ x 22 in. (36 x 56 cm).

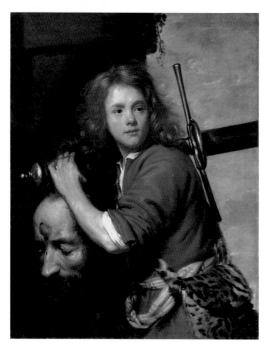

JACOB VAN OOST THE ELDER (1601–1671).
David Bearing the Head of Goliath, 1643.
Oil on canvas, 40⅛ x 31⅞ in. (102 x 81 cm).

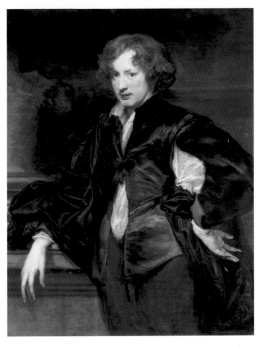

ANTHONY VAN DYCK (1599–1641).
Self-Portrait, c. 1630.
Oil on canvas, 45⅞ x 36¾ in. (116.5 x 93.5 cm).

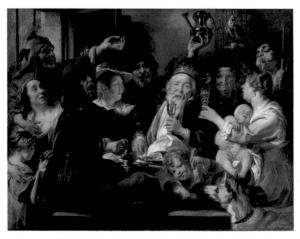

JACOB JORDAENS (1593–1678).
The Bean King (The King Drinks), c. 1638.
Oil on canvas, 63 x 83⅞ in. (160 x 213 cm).

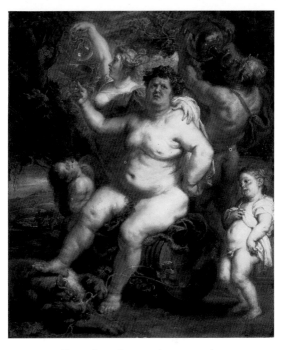

PETER PAUL RUBENS (1577–1640).
Bacchus, 1636–40.
Oil on canvas, 75¼ x 63½ in. (191 x 161.3 cm).

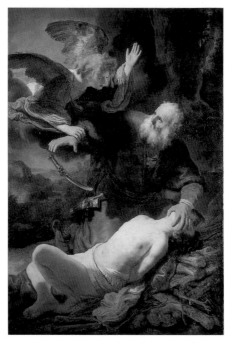

REMBRANDT VAN RIJN (1606–1669).
Abraham's Sacrifice, 1635.
Oil on canvas, 76 x 52 in. (192 x 132 cm).

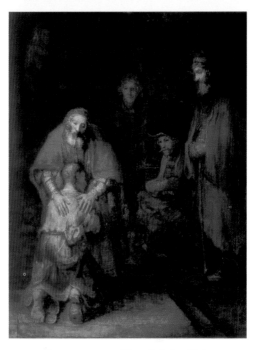

REMBRANDT VAN RIJN (1606–1669).
The Return of the Prodigal Son, c. 1666–69.
Oil on canvas, 103⅛ x 80¾ in. (262 x 205 cm).

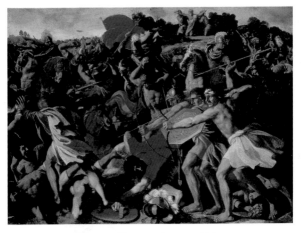

NICOLAS POUSSIN (1594–1665).
Victory of Joshua over the Amalekites, 1625–26.
Oil on canvas, 38⅜ x 52¾ in. (97.5 x 134 cm).

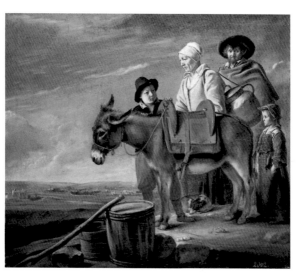

LOUIS LE NAIN (1593–1648).
The Dairymaid's Family, c. 1641.
Oil on canvas, 20 x 23¼ in. (51 x 59 cm).

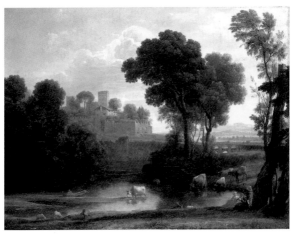

CLAUDE GELLÉE (1600–1682).
Italian Landscape, 1648.
Oil on canvas, 29½ x 39⅜ in. (75 x 100 cm).

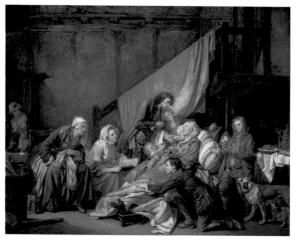

JEAN-BAPTISTE GREUZE (1725–1805).
The Paralytic, 1763.
Oil on canvas, 45½ x 57½ in. (115.5 x 146 cm).

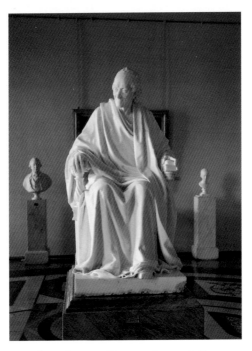

JEAN-ANTOINE HOUDON (1741–1828).
Voltaire, 1781.
Marble, height: 54⅜ in. (138 cm).

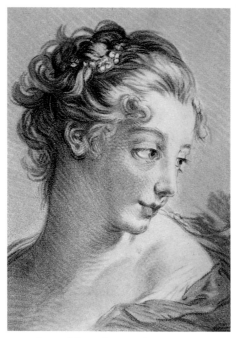

LOUIS-MARIN BONNET (1743–1793).
Young Woman, 1767. Color engraving in crayon
and pastel manner (impression on gray paper),
9¾ x 7 in. (24.8 x 17.7 cm).

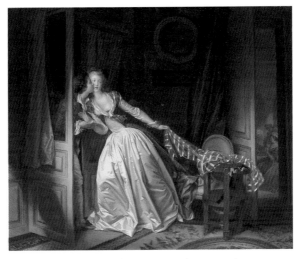

JEAN-HONORÉ FRAGONARD (1732–1806).
The Stolen Kiss, late 1780s.
Oil on canvas, 17¾ x 21⅝ in. (45 x 55 cm).

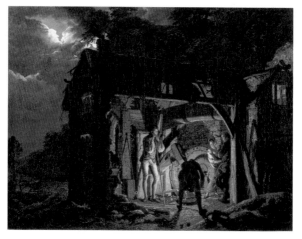

JOSEPH WRIGHT OF DERBY (1734–1797).
The Smithy, 1773.
Oil on canvas, 41⅜ x 55⅛ in. (105 x 140 cm).

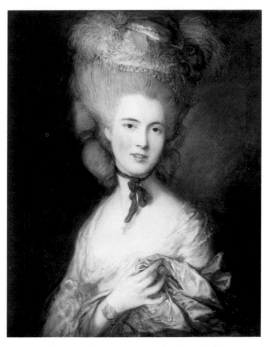

THOMAS GAINSBOROUGH (1727–1788).
Portrait of a Lady in Blue, c. 1780.
Oil on canvas, 30 x 25¼ in. (76 x 64 cm).

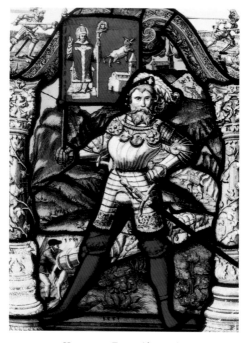

KARL VON EGERI (d. 1562).
Stained Glass with the Standard Bearer of the Landsknecht, 1551.
Colored and painted glass, lead,
19½ x 15⅛ in. (49.5 x 38.5 cm).

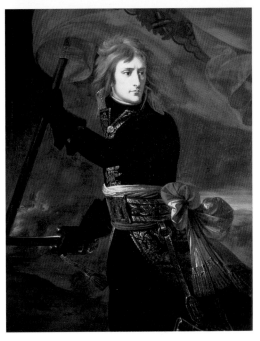

ANTOINE-JEAN GROS (1771–1835).
Napoleon on the Bridge at Arcole, c. 1797.
Oil on canvas, 52¾ x 41 in. (134 x 104 cm).

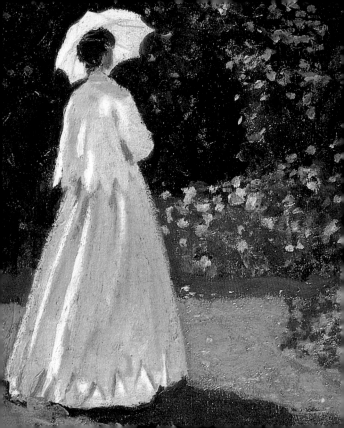

MODERN ERA: NINETEENTH AND TWENTIETH CENTURIES

The collection of nineteenth- and twentieth-century painting in the Hermitage numbers some two thousand works, including many masterpieces by the Impressionists and Post-Impressionists. The collection is remarkably comprehensive and yet at the beginning of this century the Hermitage possessed no nineteenth-century Western European paintings whatsoever. With the Revolution of 1917, however, private collections were nationalized and divided among Russia's major museums, with the Museum of Modern Western Art (later named the Pushkin Museum) in Moscow and the Hermitage as the main beneficiaries.

Thus the early nineteenth century is represented by some fine paintings by French masters, including David's *Sappho and Phaon* (page 241) and Ingres's *Portrait of Count Guriev* (page 240). Every stage of the Romantic movement can be traced in the works of such artists as François-Marius Granet, Léopold-Louis Robert, and Horace Vernet, as well as in the landscapes of Georges Michel and Gustave Doré, the oriental motifs of Eugène-Samuel-Auguste Fromentin, and the paintings of Alexandre-Gabriel Decamps and Paul Delaroche. A striking example of the Romantic movement (albeit by

1854 the movement was virtually over) is Delacroix's dramatic *Lion Hunt in Morocco* (page 245).

Salon art was extremely popular with Russian art buyers, and consequently the Hermitage has a rich selection of paintings by such artists as Jean-Louis-Ernest Meissonier, Thomas Couture, Adolphe-William Bouguereau, and Franz Xaver Winterhalter. Well represented, too, is the Barbizon School, with works by Théodore Rousseau, Daubigny, Troyon, and Corot (*Peasant Woman Tending a Cow,* page 246).

After the French, German painting comprises the second most important group in the nineteenth-century collection, but Austrian, Belgian, Dutch, Italian, Spanish, and Scandinavian artists are also represented. The 333 portraits that George Dawe painted for the Winter Palace's War Gallery of 1812, showing all of the commanders and officers who took part in the wars against Napoleon, dramatically display an aspect of British painting.

Throughout the nineteenth century private collectors in Russia were active in purchasing contemporary art and in commissioning works by foreign artists. In the mid-nineteenth century, for instance, N. A. Kushelev-Bezborodko was already selecting works by Courbet, Millet, and other painters of the Barbizon School for his gallery in St. Petersburg; he was in many respects ahead of his time. Similarly, at the turn of the twentieth century

the Shchukin and Morozov families began to assemble collections of Impressionist and Post-Impressionist art that are breathtaking for both their scope and foresight. Shchukin and Morozov were far ahead of most French and other European collectors in their enthusiasm for such artists as Monet, van Gogh, Gauguin, and, later, Matisse and Picasso.

As a result, the Hermitage's modern collection is best known for its French paintings of the late nineteenth and early twentieth century. Mostly the legacy of the Morozov and Shchukin collections, eight paintings by Monet (ranging from *Lady in a Garden* of 1867 [pages 236 and 256] to *Waterloo Bridge* of 1903), six by Renoir, two Paris scenes by Pissarro, as well as works by Sisley, Signac, Fantin-Latour, and Henri Rousseau, are equalled only by the thirty canvases of Cézanne, Gauguin, and van Gogh. The presence of Matisse, with *Dance* (page 263) and *Music* (page 262), and Picasso, with *Dance with Veils* (page 268), and *Absinthe Drinker* (page 266), further demonstrates the extraordinary prescience of the two Russian collectors, and the wealth of the Hermitage collection.

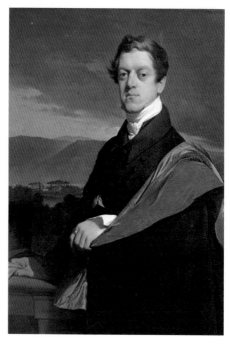

Jean-Auguste-Dominique Ingres (1780–1867).
Portrait of Count Guriev, 1821.
Oil on canvas, 42⅛ x 33⅞ in. (107 x 86 cm).

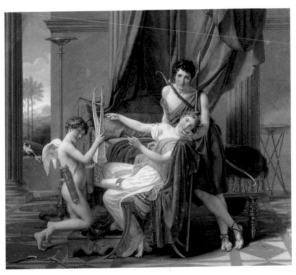

JACQUES-LOUIS DAVID (1748–1825).
Sappho and Phaon, 1809.
Oil on canvas, 88¾ x 103⅛ in. (225.3 x 262 cm).

241

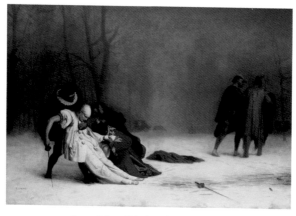

JEAN-LÉON GÉRÔME (1824–1904).
Duel after a Masked Ball, 1857.
Oil on canvas, 26¾ x 40 in. (68 x 99 cm).

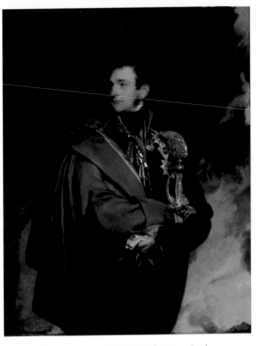

SIR THOMAS LAWRENCE (1769–1830).
Portrait of Count Vorontsov, 1821.
Oil on canvas, 56¼ x 44½ in. (143 x 113 cm).

EMILE-JEAN-HORACE VERNET (1789–1863).
Self-Portrait, 1835.
Oil on canvas, 18½ x 15⅜ in. (47 x 39 cm).

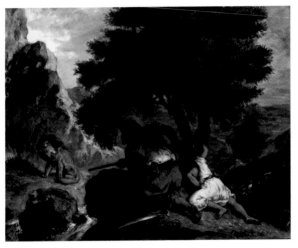

FERDINAND-VICTOR-EUGÈNE DELACROIX (1798–1863).
Lion Hunt in Morocco, 1854.
Oil on canvas, 29⅛ x 36¼ in. (74 x 92 cm).

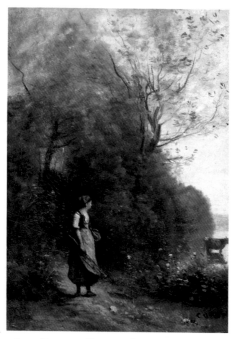

JEAN-BAPTISTE-CAMILLE COROT (1796–1875).
*Peasant Woman Tending a Cow at the Edge
of a Wood (Morning)*, c. 1865–70.
Oil on canvas, 18¾ x 13¾ in. (47.5 x 35 cm).

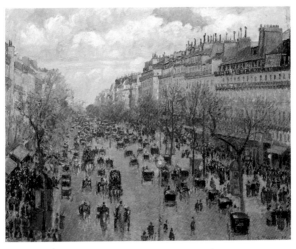

CAMILLE PISSARRO (1830–1903).
Boulevard Montmartre, Paris, 1897.
Oil on canvas, 29⅛ x 36½ in. (74 x 92.8 cm).

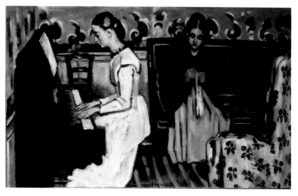

PAUL CÉZANNE (1839–1906).
Girl at the Piano (Overture to Tannhäuser), c. 1867–68.
Oil on canvas, 22¾ x 36⅜ in. (57.8 x 92.5 cm).

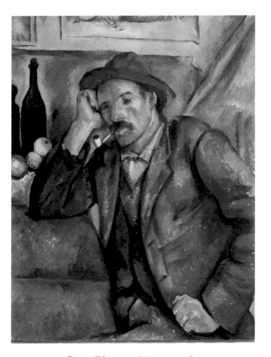

PAUL CÉZANNE (1839–1906).
The Smoker, c. 1890–92.
Oil on canvas, 36⅜ x 29 in. (92.5 x 73.5 cm).

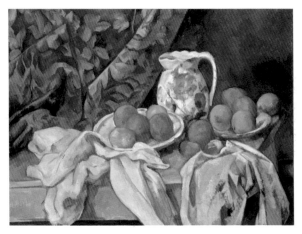

PAUL CÉZANNE (1839–1906).
Still Life with Drapery, c. 1894–95.
Oil on canvas, 21⅝ x 29⅜ in. (55 x 74.5 cm).

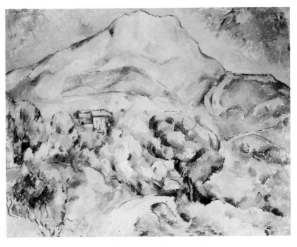

PAUL CÉZANNE (1839–1906).
Mont Ste-Victoire, c. 1896–98.
Oil on canvas, 31 x 38¾ in. (78.5 x 98.5 cm).

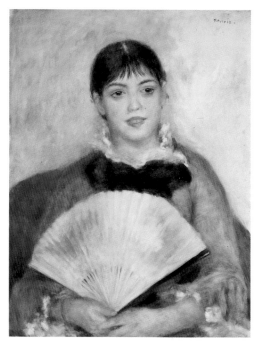

PIERRE-AUGUSTE RENOIR (1841–1919).
Girl with a Fan, c. 1881.
Oil on canvas, 25½ x 19⅝ in. (65 x 50 cm).

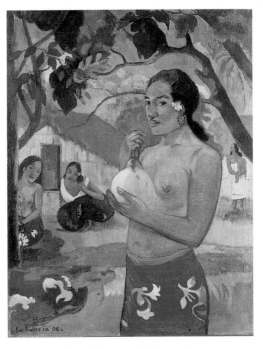

PAUL GAUGUIN (1848–1903).
Eu Haere ia oe (Woman with Fruit), 1893.
Oil on canvas, 36¼ x 29 in. (92 x 73.5 cm).

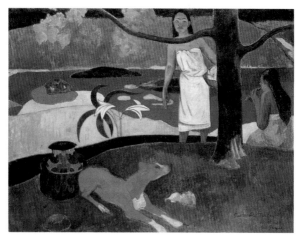

PAUL GAUGUIN (1848–1903).
Tahitian Scene, 1892.
Oil on canvas, 34½ x 44¾ in. (87.5 x 113.7 cm).

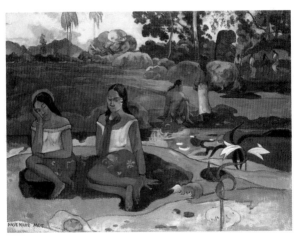

PAUL GAUGUIN (1848–1903).
Nave Nave Moe (Sacred Spring), 1894.
Oil on canvas, 29⅛ x 39⅜ in. (74 x 100 cm).

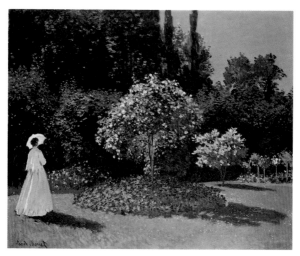

CLAUDE MONET (1840–1926).
Lady in a Garden (Ste-Adresse), 1867.
Oil on canvas, 32⅜ x 40 in. (82.3 x 101.5 cm).

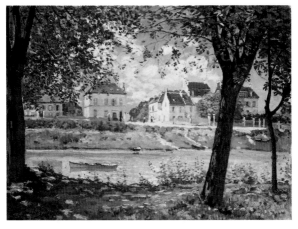

ALFRED SISLEY (1839–1899).
Villeneuve-la-Garenne, Village on the Seine, 1872.
Oil on canvas, 23¼ x 31⅝ in. (59 x 80.5 cm).

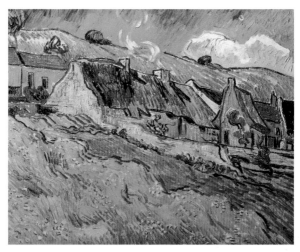

VINCENT VAN GOGH (1853–1890).
Thatched Cottages, 1890.
Oil on canvas, 23½ x 28½ in. (59.5 x 72.5 cm).

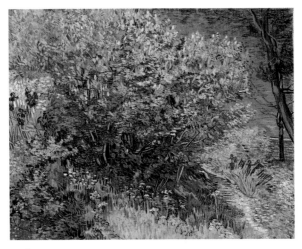

VINCENT VAN GOGH (1853–1890).
The Lilac Bush, 1889.
Oil on canvas, 28¾ x 36¼ in. (73 x 92 cm).

VINCENT VAN GOGH (1853–1890).
Memory of the Garden at Etten (Ladies of Arles), 1888.
Oil on canvas, 28¾ x 36¼ in. (73 x 92 cm).

HENRI MATISSE (1869–1954).
View of Collioure, c. 1905.
Oil on canvas, 23½ x 28¾ in. (59.5 x 73 cm).

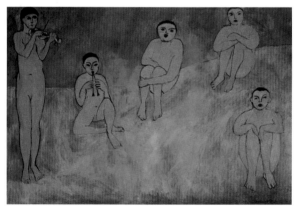

HENRI MATISSE (1869–1954).
Music, 1910.
Oil on canvas, 102⅜ x 153⅛ in. (260 x 389 cm).

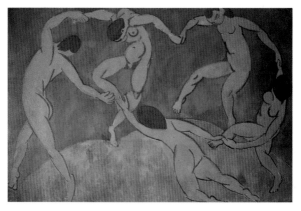

HENRI MATISSE (1869–1954).
Dance, 1910.
Oil on canvas, 102⅜ x 154 in. (260 x 391 cm).

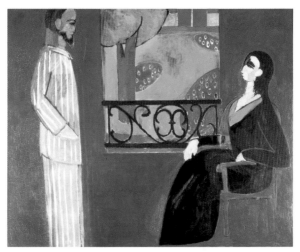

HENRI MATISSE (1869–1954).
The Conversation, 1909–11.
Oil on canvas, 69⅝ x 85½ in. (177 x 217 cm).

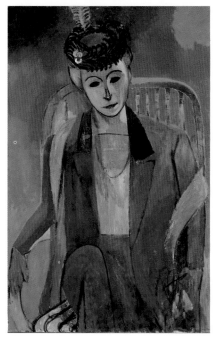

HENRI MATISSE (1869–1954).
Portrait of the Artist's Wife, 1913.
Oil on canvas, 57½ x 38¼ in. (146 x 97 cm).

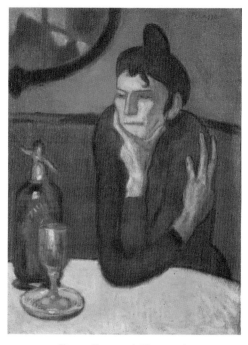

PABLO PICASSO (1881–1973).
The Absinthe Drinker, 1901.
Oil on canvas, 28¾ x 21¼ in. (73 x 54 cm).

PABLO PICASSO (1881–1973).
Portrait of Benet Soler, 1903.
Oil on canvas, 39⅜ x 27½ in. (100 x 70 cm).

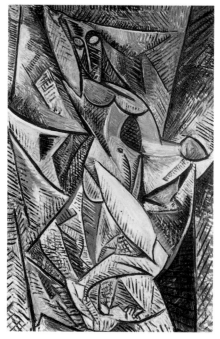

PABLO PICASSO (1881–1973).
Dance with Veils, 1907.
Oil on canvas, 59⅞ x 39¾ in. (152 x 101 cm).

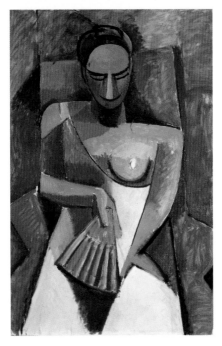

PABLO PICASSO (1881–1973).
Woman with a Fan, 1908.
Oil on canvas, 59 x 39⅜ in. (150 x 100 cm).

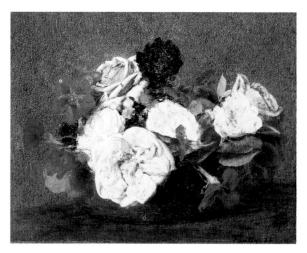

HENRI FANTIN-LATOUR (1836–1904).
Roses and Nasturtiums in a Vase, 1883.
Oil on canvas, 11 x 14¼ in. (28 x 36 cm).

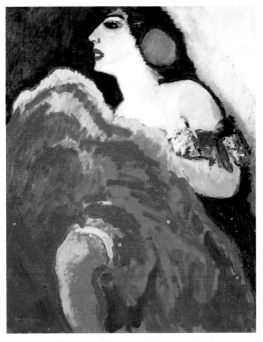

KEES VAN DONGEN (1877–1968).
Red Dancer, c. 1907–8.
Oil on canvas, 39¼ x 31⅞ in. (99.7 x 81 cm).

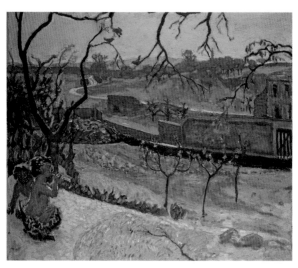

PIERRE BONNARD (1867–1947).
Early Spring (Little Fauns), c. 1909.
Oil on canvas, 40⅛ x 49¼ in. (102 x 125 cm).

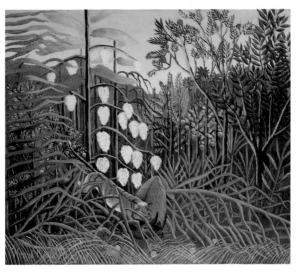

HENRI ROUSSEAU (1844–1910).
Battle Between Tiger and Bull (In a Tropical Forest), 1908.
Oil on canvas, 18⅛ x 22 in. (46 x 56 cm).

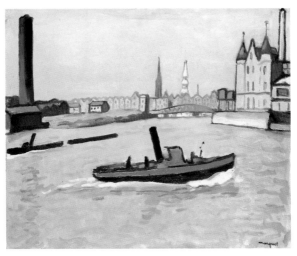

ALBERT MARQUET (1875–1947).
The Port of Hamburg, 1909.
Oil on canvas, 26⅛ x 31½ in. (66.5 x 80 cm).

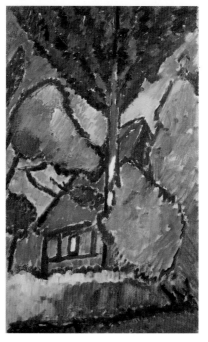

ALEXEI VON JAWLENSKY (1864–1941).
Landscape, c. 1910.
Oil on cardboard, 20⅞ x 12¾ in. (53 x 32.5 cm).

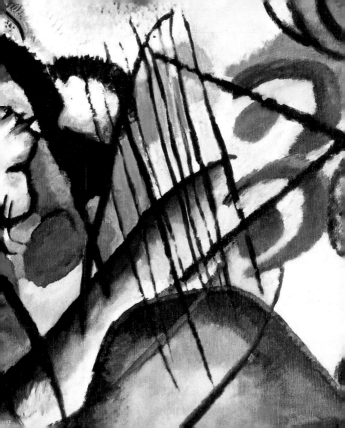

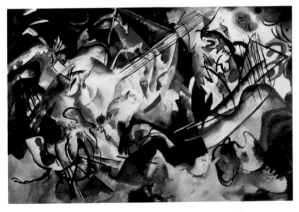

WASSILY KANDINSKY (1866–1944).
Composition No. 6, 1913.
Oil on canvas, 76¾ x 118⅛ in. (195 x 300 cm).

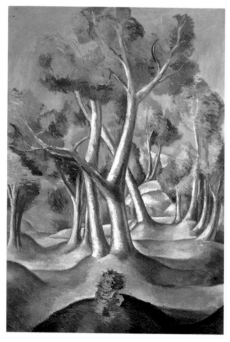

ANDRÉ DERAIN (1880–1954).
The Grove, 1912.
Oil on canvas, 45⅞ x 32 in. (116.5 x 81.3 cm).

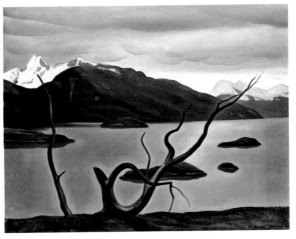

ROCKWELL KENT (1882–1971).
Admiralty Sound, Tierra del Fuego, 1922–25.
Oil on cardboard, 33⅞ x 44 in. (86 x 112 cm).

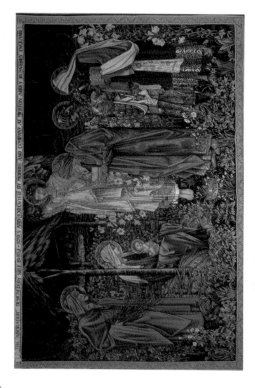

The Adoration of the Magi, late 19th century.
William Morris and Co., after a design by Sir Edward Burne-Jones
(1833–1898). Wool, 100⅜ x 149¼ in. (255 x 379 cm).

INDEX OF ILLUSTRATIONS

281

286

Editors, Abbeville Press: Jackie Decter and Jeffrey Golick
Editor, Booth-Clibborn Editions: Mark Sutcliffe
Designer: Kevin Callahan
Production Editor: Meredith Wolf
Production Manager: Lou Bilka

First edition
10 9 8 7 6 5 4 3 2 1

Library of Congress Cataloging-in-Publication Data
Treasures of the Hermitage / Introduction by Vitaly Suslov.
 p. cm.
 "A tiny folio."
 Includes index.
 ISBN 0-7892-0104-6
 1. Art—Russia (Federation)—Saint Petersburg—Catalogs.
2. Gosudarstvenny i Ermitazh (Russia)—Catalogs.
N3350.T74 1996
708.7'453—dc20 96–13374

SELECTED TINY FOLIOS™ FROM ABBEVILLE PRESS

- American Impressionism 1-55859-801-4 • $11.95
- Angels 0-7892-0025-2 • $11.95
- The Great Book of French Impressionism 1-55859-336-5 • $11.95
- Japanese Prints: The Art Institute of Chicago 1-55859-803-0 • $11.95
- The North American Indian Portfolios:
 Bodmer, Catlin, McKenney & Hall 1-55859-601-1 • $11.95
- Treasures of British Art: Tate Gallery 1-55859-772-7 • $11.95
- Treasures of Folk Art 1-55859-560-0 • $11.95
- Treasures of Impressionism and Post-Impressionism:
 National Gallery of Art 1-55859-561-9 • $11.95
- Treasures of the Louvre 1-55859-477-9 • $11.95
- Treasures of the Musée d'Orsay 1-55859-783-2 • $11.95
- Treasures of the Musée Picasso 1-55859-836-7 • $11.95
- Treasures of the Museum of Fine Arts, Boston 0-7892-0146-1 • $11.95
- Treasures of the National Gallery, London 0-7892-0148-8 • $11.95
- Treasures of the National Museum of the
 American Indian 1-55859-603-8 • $11.95
- Treasures of 19th- and 20th-Century Painting:
 The Art Institute of Chicago 1-55859-603-8 • $11.95
- Treasures of the Prado 1-55859-558-9 • $11.95
- Treasures of the Uffizi 1-55859-559-7 • $11.95
- Women Artists: The National Museum of Women in the Arts
 1-55859-890-1 • $11.95